Making Family Websites

Fun & Easy Ways to Share Memories

Making Family Websites

Fun & Easy Ways to Share Memories

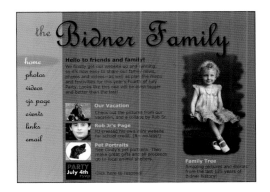

by Jenni Bidner

LARK BOOKS

A Division of Sterling Publishing Co., Inc.
New York

Cover Design: Barbara Zaretsky
Cover Photographs: Monitor, dog, and soccer photographs © Jenni Bidner; flower girls photograph © Jan Press Photomedia, Livingston, NJ; tourist photograph © Barbara Zaretsky
Book Design and Layout: Jenni Bidner
Photography: All photos © Jenni Bidner, unless otherwise specified.
Product photographs provided courtesy of the manufacturers.
Websites: Pages 8 and 97 © Sandy Knight; page 12 © Ari Savar; page 15 © Gayla Combes; page 73 and 77 © Russell Marcus; page 132 © Michelle Lee

Library of Congress Cataloging-in-Publication Data

Bidner, Jenni.
 Making family Websites: fun & easy ways to share memories / by Jenni Bidner.
 p. cm.
 ISBN 1-57990-445-9 (pbk.)
 1. Web site development—Amateurs' manuals. I. Title.

TK5105.888.B52 2003
005.2'76—dc21

2003047447

10 9 8 7 6 5 4 3 2 1

Published by Lark Books
a division of Sterling Publishing Co., Inc.
387 Park Avenue South, New York, N.Y. 10016

© 2003, Jenni Bidner

Distributed in Canada by Sterling Publishing, c/o Canadian Manda Group,
165 Dufferin Street, Toronto, Ontario, Canada M6K 3H6

Distributed in the U.K. by Guild of Master Craftsman Publications Ltd., Castle Place,
166 High Street, Lewes, East Sussex, England BN7 1XU, Tel: (+ 44) 1273 477374,
Fax: (+ 44) 1273 478606,Email: pubs@thegmcgroup.com, Web: www.gmcpublications.com

Distributed in Australia by Capricorn Link (Australia) Pty Ltd.,
P.O. Box 704, Windsor, NSW 2756 Australia

If you have questions or comments about this book, please contact: Lark Books, 67 Broadway, Asheville, NC 28801, (828) 253-0467

Manufactured in China
ISBN 1-57990-445-9

About the Author

Jenni (Jen) Bidner is the author of seven books on photography and one on search and rescue dogs, entitled *Dog Heroes: Saving Lives & Protecting America.* She is the former editor of *Petersen's Photographic, Outdoor & Travel Photography, Canon Insight,* and other magazines. Her photographs and articles have appeared in numerous magazines and newspapers around the world.

In her spare time, Jen is a member of the volunteer canine (K9) search and rescue community, training and handling her two search dogs Yukon (German shepherd) and Ajax (German shorthair pointer, pictured).

Jen Bidner lives in the Chicago area and can be contacted by email at bidner@mail.com.

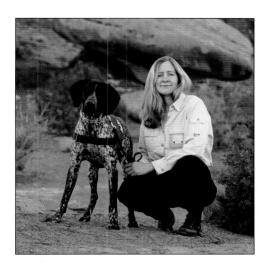

Photo Credits

Most of the images in this book were created by Jen Bidner or were clip art provided in the web design software mentioned in the book.

The author would like to thank the following artists and photographers for the use of their images: David Bidner (photo of boy on pages 19 and 74); Don Blair (wedding photographs on pages 18 and 51, taken for PhotoAlly); Russ Burden (before-and-after photos on pages 36 and 45); Dr. Gayla Combes, DVM (drawing of dog on pages 8, 81, and 103, and websites on page 15); Cheryl Croston (flower photo on page 119); Michelle Lee (Patterns from the Past website on page 132); Russell Marcus (websites on page 73 and 77); Bryan Ryndak (photo of girl and dog, page 24); Ari Savar (website on page 12); Robert Thien (the baby photographs in sample websites on pages 13, 74, 102, and 114); and Meleda Wegner (photo, this page).

THE SMITHS

2003 was a great summer for us, with lots of poolside fun & a trip back to Oklahoma. Click on the links to see our photo, video and hear the latest news!

Home
News
Stories
Links
E-mail

Previous Next

iMac

Table of Contents

Introduction

WHAT YOU'LL LEARN IN THIS BOOK:

- **How websites work**
- **Picking the right host**
- **Securing a site name**
- **Cool elements you can add**
- **Digitize your photos for the Web**
- **Hints on taking better photos**
- **Improving images with software**
- **Creative design & content ideas**
- **Link, load, & launch your site!**

Computers and computer activities have become an important part of many Americans' lifestyle. People who never really had a reason to use computers are now using them daily at work, surfing the Internet for entertainment and research, shopping online, and keeping in touch with friends and family through emails.

And let's face it, our kids look like magicians as their fingers fly across the keyboard with lightning speed.

Below: You can use your website to share news, display photos, organize events, or even run a small home business.

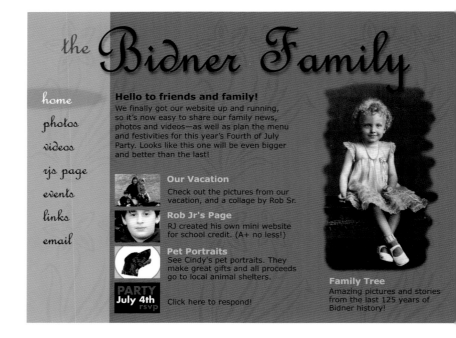

Why a Family Website?

Most large companies and many small businesses have their own websites. But while the business website acts as the modern cyber-storefront, the family website is much, much more.

Metaphorically, the family website is the fireplace around which everyone can gather to share stories. It can also serve as the most modern of wedding and photo albums, or the replacement for the "telephone chain" we used to spread news about family, club, or sporting events.

Your family website can also be a learning project for your kids, helping them build self-esteem. You can use the site to share your hobbies and knowledge with other enthusiasts. You can promote your home business or increase online auction sales.

And last, but not least, your site can be a powerful outlet for personal expression.

The Goal of this Book

My goal is to provide you with the information you need to quickly develop your own website. I'm *not* going to teach you how to write code and become a high-powered web designer. But I will show you how to access and utilize easy (and inexpensive) software that can get you up and running with a great-looking website in just *hours*!

Modern WYSIWYG ("what you see is what you get") software provides drag-and-drop simplicity to web design. It's hard to believe that, today, the toughest part of building a family website is deciding what to include!

There Are Many Ways to Use Your Website

- ❏ Sharing news (page 102)
- ❏ Celebrating family milestones & achievements (page 104)
- ❏ Family events & reunions (page 106)
- ❏ Kids' websites (page 108)
- ❏ School projects (page 110)
- ❏ Genealogy & family tree (page 112)
- ❏ Vacation logs in real time (page 114)
- ❏ Sharing pictures & art (page 116)
- ❏ Sharing your hobbies or other expertise (page 120)

- ❏ Your pet's pages (page 122)
- ❏ Team/club pages (page 124)
- ❏ Interactive party planning (page 126)
- ❏ Not-for-profit fundraising (page 128)
- ❏ Tributes & memorials (page 128)
- ❏ Calendars (page 129)
- ❏ Bulletin/message boards (page 129)
- ❏ Home businesses (page 130)
- ❏ Online recipe book (page 130)
- ❏ Affiliate Programs (page 131)
- ❏ Online resumes (page 133)

Chapter 1

Getting Started!

In this chapter:

- Overview
- Finding the right host
- Privacy & security issues
- How will it look?
- Mac vs. PC
- All about digital photos
- Software for web design

If you have mastered emails and Internet shopping, you won't have any trouble taking the leap to creating a family website. Free and inexpensive software make it as easy as creating a Word or PowerPoint document.

Overview of the Process

I could go on for pages about the nuances of the Internet, how it works and its future. But all you really need to know to post your website are these six facts:

1. The Role of Hosts

There is *not* an Internet warehouse out in cyberspace where all the information on the Web is stored. The burden of housing the information goes to individual Internet host companies. This host will "hold" all the files pertaining to your website, and allow outside computers to access it through your Internet address.

2. Find the Right Host

You should probably first check your Internet service provider (ISP), such as AOL or Earthlink. Many give their subscribers a free homepage with their

Review of Hosting Considerations

INTERNET SERVICE PROVIDER

Start your search for a host with your Internet Service Provider (ISP). The company may already include web hosting with your monthly service charge.

Most likely, this "free" service comes with a small file size limit, or even a single-page cap. But often for a small fee it can be enlarged.

ADS vs. AD-FREE SITES

If you don't mind having banners and advertisements appearing on your site, you may be able to get free site hosting from several Internet hosting companies. Unfortunately, you'll have no control over what banners and pop-ups will appear on your site. There are also major size restrictions. But free is free, and it's a nice way to test the waters.

EASY SITE NAMES

If you want to avoid the hassle of registering your domain name, some hosts provide this service for you as part of their fees. This includes renewal of the name annually.

Other hosts give you names that start with the company address, such as www.homestead.com/bidner1. For an extra fee, some hosts allow you to have another, simpler address blindly

forwarded to their longer one. So, your visitor could just type the easier-to-remember www.JenBidner.com and she would automatically be sent to the more complicated address.

PROVIDED SOFTWARE

Hosts like Homestead, Lycos/Tripod and Yahoo/Geocities provide online software for building your site. It's easy to use without knowing a word of code, and you'll also get plenty of templates as well as nice clip art for free usage. Site-enrichment applications, such as slide shows, guest books, instant messaging, and databases are provided by some.

SOFTWARE LIMITATIONS

The downside to many hosts that provide free online software is that you must use their software. You can't build your site with Web Easy or FrontPage and then simply upload it. Likewise, you can't take the website you just built with their software and bring it to a new host if you are unhappy with the first host's service.

E-COMMERCE OPTIONS

If you plan on doing financial transactions through your site, check on the compatibility of the host and the e-commerce services it offers.

monthly subscription. Sometimes this is *only* a homepage, without the option of additional linked pages.

Many hosts even have simple web-building software that helps you get started quickly, although it tends to be limited and more complicated than some of the inexpensive WYSIWYG-type software kits you can purchase for under $60.

The biggest disadvantage of the "free" or inexpensive hosting plans offered by Internet service providers are the file size limits they place on users. You're only allowed to store so many megabytes of information, or they may even limit you to a single page.

But it's a good place to start, especially if it's free with your regular service. At the very least, you can include a link (or if links aren't allowed, a written reference) to your "real" site on another host. They may even allow you more space if you upgrade to premium service.

Another option is free or inexpensive monthly hosting from an outside company. Be aware that "free" hosts may put ads on your site, and inexpensive hosts have major size and other limitations.

3. Design Your Site

You design your website on your home computer using special web-authoring software that you either purchase or access from your host.

Today, WYSIWYG ("what you see is what you get") software makes creating a website a breeze. You no longer need to learn or use the tedious code of web languages because these programs do it for you.

Stand-alone software is loaded onto your computer. You design the site and, when you're ready, upload the final files to an Internet host. New versions are remarkably inexpensive, many priced under $40.

The other type of WYSIWYG software is already online and available through your host. You design the site while logged onto the site. When you're ready to go live, you simply click on the PUBLISH (or similarly named) function.

The advantages of online software are that you do not have to invest in the software yourself, it's easy to use, and the host offers technical support if you have problems. The big disadvantage in using a host's online software is that should you become unhappy with the host's service,

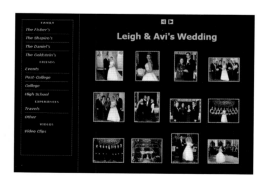

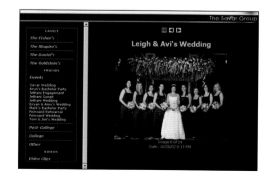

Left: Lee and Avi Savar used their site to share their wedding with friends and family.

Right: Online software, like that offered by the hosting company Homestead, enables you to create a homepage in a matter of minutes. Just pick a template, select graphic elements and substitute in your own photos and text.

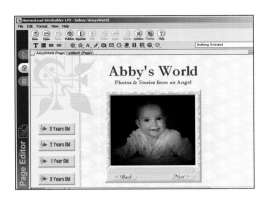

you cannot take your site design and publish it on another host's site. You'd have to build it again from scrap, and you may not have access to the same graphical elements the previous host supplied.

4. Get a Domain Name

In order for people to find your site, you will need to register for a domain name. This is a word or phrase, preceded by "www." and followed by ".com" or one of the many new variations (NET, ORG, INFO, BIZ, WS, US, etc.). Avoid punctuation such as dashes or underscores, as these can be confused in the typing. If your preferred name is already taken, you can get creative add the word "family" to make the name "www.smithfamily.com" instead.

You can register on your own by using one of the many companies that do "domain registration" (including many hosting companies). You'll be charged a fee, and you'll have reregister annually or biannually or your domain name can be purchased by someone else.

Some hosts provide the name as a variation of their own company's site name followed by your individual name, such as "www.homestead.com/johnsmith232." This name tends to be long and hard to remember.

If you are worried about security, don't include your last name in the description. (See page 14 for more information.)

5. Upload Your Site

Use your Internet service provider (ISP) to access the Internet. Go onto your host's site and upload the design file, too, and all the elements it includes (pictures and downloadable files) to this host.

The transfer process from your computer to the Internet host requires FTP protocols. Luckily, FTP protocols have become much simpler today—to the point that most online and standalone WYSIWYG-type software has it built in and hidden in drag-and-drop simplicity. Just drag the files from one window to the other and the software does the rest. If the transfer process is not automated like this, there are shareware and freeware FTP programs available, such as Fetch.

6. Open for Business!

Your host company stores the information on its server, which is basically a supercomputer that allows other computers to talk to it. When someone logs onto the Internet and types in your website name (or clicks on a link to one of your pages), it is directed to the address of your host. This host then allows the visitor to download the information through their Internet browser so it can be viewed on the visitor's computer.

Privacy and Security

In terms of e-commerce and shopping on the Internet, security has come a long way! You used to have to send credit card information in multiple emails to avoid possible interception by the "bad guys." Today, connections are designed for safe purchases and provide very secure transactions.

However, anything *you* post on the Internet is accessible by the general public unless you take very proactive (and complicated) steps. Unless someone knows your domain name, or it is close enough to another site name to be accidentally typed in, most people won't *accidentally* hit your site—your friends and family will get there via a link you send them. Unfortunately, you have no control over friends and family who might send your website address on to others.

The general rule of thumb is, if you don't want the general public to see something, *don't* put it on a website. Send the information as a letter or email. Or put your picture in a private gallery run by an online photofinisher such as shutterfly.com or ofoto.com.

Most web designers spend *enormous* amounts of energy trying to figure out how to get search engines like Yahoo, AltaVista, Google, and others to pick up their pages. They utilize metatags (see page 78) to supply pertinent key words that "spider" search engines can find automatically.

However, if privacy is your concern, just leaving out metatags will help. But many of these spiders will skim pages without metatags, looking to pick up key words

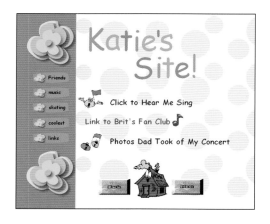

Left: For safety reasons, Katie's site does not include her family name or any reference to her address or hometown. Some hosts will also allow you to password-protect the page, so it can only be accessed by friends and family.

off your homepage. Even putting in "no index, no follow" robot code into the metatag (an advanced programming function that tells the search engine to ignore this site) is no guarantee. The search engine may still pick it up, because the technology is being constantly updated and changed.

For instance, if you are worried about someone learning your child's first and last name, start by keeping your family name off the site and don't include information on your city of residence.

It is important to note that there are other ways for the determined to find out your last name, including the name under which you registered your domain name or through your email name. You can get an extra layer of anonymity by registering your domain name by proxy. In this case, a company (such as Domains by Proxy) will register it for you for a fee, yet allow you to maintain all your benefits of ownership.

Another advanced solution is to include passworded sections on your site. You've seen them before on commercial sites as "members only" areas. If this is important

to you, check that it is included in the software you are considering buying or on the host you have chosen. Family-oriented hosts like MyFamily.com will give you private, passworded sites.

There are also several JavaScript applications you can add to password-protect your site. Most of these "mini-programs" are easy for web designers to get around, but they will help keep the uninitiated out.

Your Site Doesn't Look Right?

If you've done your share of Internet surfing, I'm sure you've been frustrated a few times by coming across a website where you have to do a lot of scrolling just to read it or view a picture, or (the opposite) it looks tiny and hard to read on your monitor. Very frustrating!

This is caused by several factors. Different monitors display a different number of pixels. The early color monitors were 640x480, while many newer monitors can handle 1024x768 *and* have settings that let you adjust it to different levels.

This means that if you want to be sure that *everyone* can see your website without scrolling right or left, it should less than 600 pixels in width (640 pixels, minus the space taken by the browser frame and your operating system). Unfortunately, on these newer computers this same site will look tiny. If Grandma is your most

Right: The images at right are how one website appears on a 17-inch (43.2 cm) PC monitor at different settings. Clockwise from upper left, they are: 800x600 pixels, 1024x768 pixels, 1152x864 pixels, and 1280x1024 pixels.

important visitor and she uses an ancient computer, you might want to play it safe and go small (or buy her a new computer for her birthday!).

Luckily, some modern WYSIWYG web design software now use *percentages* instead of pixels to determine the page size, meaning it will automatically adjust to the monitor size. If you're doing it yourself, plan on doing a little math to determine that certain elements will be a certain percentage of the total in width.

Other WYSIWYG software makes the decision based on the larger computer monitors or other default settings. Either way, you probably won't be faced with the decision yourself in this type of software.

Above the Fold

Unless you keep your website pages short (in terms of top to bottom), your viewers may be forced to scroll.

There is an old newspaper term called "above the fold." The idea behind it was that all the important information (the hot stuff that would sell the paper) needed to be above the fold in the center, so that the

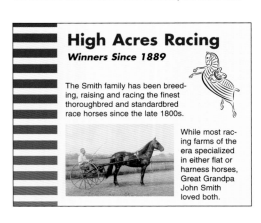

High Acres Racing
Winners Since 1889

The Smith family has been breeding, raising and racing the finest thoroughbred and standardbred race horses since the late 1800s.

While most racing farms of the era specialized in either flat or harness horses, Great Grandpa John Smith loved both.

Wisely he split the training responsibilities between his two sons, with Mark taking the harness horses, and Tommy training the thoroughbreds.

Cousins Wayne and Mel, being smaller and more athletic than Tommy and Mark, were the jockeys and drivers for all but the champion Divine Girl. For this famous stakes winner, one of the best jockeys of the era was hired by High Acres Racing.

Divine Girl was one of the winningest fillies to ever come out of the Ohio River Valley, winning 22 of 23 starts.

She went on to produce six foals, including Divine Dan shown at right. Dan won three stakes races as a two-year-old but retired due to injury before his third year.

Although High Acres Racing never produced a harness horse of Divine Girl's caliber, they had four who were the highest purse winners in Ohio during select years in their racing career. Best know among the pacers was High Acres Sam, who broke set a track record at River Downs.

In 1920, High Acres Racing saw it's darkest day, when a fire destroyed 50% of of the buildings. Luckily all the farm hands and horses were saved from the devastating blaze.

1902 was also the birth of young Elizabeth was born. She inherited the farm in the 1950s and brought it to it's current success.

High Acres Racing
Winners Since 1889

The Smith family has been breeding, raising and racing the finest thoroughbred and standardbred race horses since the late 1800s.

While most racing farms of the era specialized in either flat or harness horses, Great Grandpa John Smith loved both.

Left: If you don't mind making your visitor scroll down to see your page, it can be very long. However, remember that only a small portion of it will be visible at any one time.

Far Left: The concept of "above the fold" is that the visitor should be able to see the most vital information without having to scroll.

potential buyers could see it in a glance without picking it up and opening it. That means the important parts of your site need to be located within the first 300 pixels of the site to be viewed on a small monitor.

PC vs. Mac

To make matters more difficult, most PC monitors display information at 96 pixels per inch (ppi), while most Macintosh computer monitors are set to 72ppi. And Multiscan monitors can be set even higher. This means that a standard 300x450-pixel image will look larger on the Mac set at 75ppi than on the PC set at 100ppi at the standard settings.

Different Browsers

Still another hitch are the different Internet browsers. For instance, even the two most popular Internet browsers, Netscape and Internet Explorer, will display some websites differently. And older versions might not be able to display new picture formats, specialized animations, or other new or specialized functions.

Even if your visitor is using the same browser as you, your site might look different on the Macintosh version of the Internet browser compared to the PC version. Among the changes you might see are: substituted (default) type fonts replacing the ones you had carefully chosen; photos not lining up as planned; or the site appearing "gappy" as it flows in unexpected ways.

If it looks good on your monitor, don't believe blindly that it will look great on

Right: If you want to let people know that a new page on your site will be appearing soon, include a link to an "under construction" page. Do this sparingly, because it can be frustrating for the visitor to waste time jumping to "useless" pages.

your friends' and family 's monitors. You need to test it on as many browsers and platforms as you can to make sure it looks good on them as well.

The DISPLAY function found in the control panel of newer computer operating systems will allow you to set the monitor to different pixel sizes, so you can mimic what it could look like on older computer monitors.

You should also test all the links and visit all your pages to make sure you didn't accidentally type in an incorrect file name, which could result in a missing photo or element or a broken link.

Maintenance

Plan on scheduling regular "maintenance" to your site. For instance, don't bother putting in a calendar, if you're not going to update it regularly! It looks silly to still have January's information up when it's already March.

Also, when you change your email address, make sure you update the internal links. And if you include a Favorite Links page, test the links to other sites frequently to be sure they are still up to date.

Patience, Please!

WE'RE UNDER CONSTRUCTION

(Check back in January)

An Explanation of Digital Photos

Some of the most important elements in your website will be photographs. However, in order to be on your site, the images must be digital.

This does *not* mean that you need to use a digital camera. Your prints, negatives, and slides can easily be "digitized" so you can add them to your website. Likewise, any relatively flat object can be scanned and made into a digital photo.

WHAT IS A DIGITAL PHOTO? A digital picture is simply a photo that has been converted into "computer language" and saved as a file. This can be done directly with a digital camera. Or, you can scan conventional images to convert them.

Just like a word processing file, a digital picture file can be saved on your hard drive or a floppy disk, CD, or other media. It can be attached to an email and sent over the Internet, or posted to your website.

WHAT IS A PIXEL? When an image is created either by a digital camera or a scanning device, it is recorded in many individual pieces called pixels. Each pixel is assigned color and tonal values (limited only by the capability of the input device). When the pixels are put together like a jigsaw puzzle, a complete image is created. These pixels are evenly spaced along a grid, although new technology may make

"random" patterns (that more closely mimic film) more common.

The actual size of a digital image is usually stated in pixels, such as 300x450 pixels, or the total number of the pixels (the resolution). A one-megapixel camera shoots pictures at 1,000,000 pixels or approximately 800x1200 pixels. This is far too large for use in a website and must be "resized" for web usage.

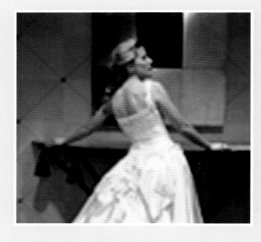

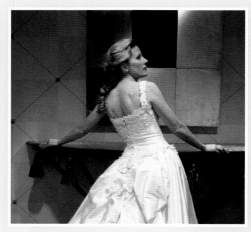

A 300x450 pixel image will appear about the size of a typical snapshot on your monitor. If you were to print it on your home printer, you would need to make it smaller to get photo quality (2"x3" [5x7.6 cm] or less). If you were to print it at 20"x30" (50.8x76.2 cm), it would look grainy and almost unrecognizable as a photo.

Higher-resolution picture files give you more choices, because you can print them large or small with good results, whereas you can't print low-resolution pictures big and hope to get photo quality.

However, if you put a high-resolution picture on your website, it will eat up file space, take "forever" for your visitor to download the page, and may appear huge on their monitor, requiting them to scroll to see the full picture.

BIT DEPTH: In addition to the number of pixels in a photograph, the bit depth of those pixels is important. Information assigned by computers to pixels are measured as bits or bytes.

A one-bit pixel can create a pixel that is either white or black. This is *not* the same as a "black-and-white photo," which is really made up of shades of gray (GRAYSCALE). Instead, it is just *black* and *white*.

8-bit (one-byte) pixels can display one of 256 colors, which gives a photo choppy colors. Very old color monitors can only display 256 colors, but few are still in use.

Pixels that contain three bytes (24-bit) or more give you over 16 million choices, allowing the smooth, realistic gradation of color. Most modern digital cameras and scanners produce 24-bit or higher images, and most computer monitors can now display them adequately.

PIXELS EQUAL MEMORY: Since high-resolution pictures look more realistic than low-res ones, why would anyone ever consider working with less than the highest resolution possible? These high-resolution images are unfortunately memory hogs and have large—if not *huge*—file sizes.

The higher your resolution, the longer it takes the computer to open and alter your photos. And, if you post them to your site, it could take some viewers hours to download your site—if they even could! Therefore, you may need to resize your images to a "web-friendly" size. See page 90 for details.

1-Bit

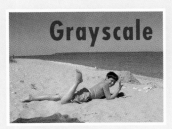

Grayscale

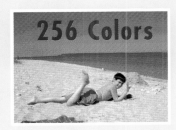

256 Colors

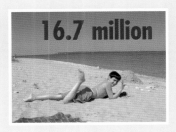

16.7 million

Web Design Software

In the "old days" of the Internet, you had to have a vast amount of knowledge to program the "language" of the Internet. HTML, the most basic Internet scripting language, is not complicated to learn but it is time-consuming. Add Java, Flash Graphics, dHTML, Cascading Style Sheets, or some of the other new scripting languages, and you have to learn even more.

Have no fear, however! There is now a cadre of new software programs that completely hide the programming language, allowing you to design a website as easily as you create a Microsoft Word document.

Some of these programs are offered online as part of your host's monthly fees. Others are standalone software programs that you purchase and load onto your computer. For reasons of convenience, the term WYSIWYG ("what you see is what you get") will refer to both types.

The only real downside of WYSIWYG web design programs are their limits in

Right: Software like Web Easy shows you the website as it will look when launched (WYSIWYG, what you see is what you get).

what they can deliver and their wastefulness in terms of memory size of the code. If you're designing a 1,000-page website for a company, any extra size is a burden. But for a relatively simple family site, this is rarely an issue if you size your images well.

Some programs like V Communications' Web Easy (VCOM), are under $40. Web Easy is quick and easy to get started with, especially if you use its templates. Internet Design Shop XL has a little less drag-and-drop simplicity, but it is a powerful basic program and priced under $60.

FrontPage (Microsoft) is more pricey at over $100, but it offers a nice mix of

WYSIWYG simplicity plus templates and advanced code editing. Microsoft bills it as a program that "works with you as you learn more and more about website creation and management." It offers excellent e-commerce functionality, forms and database support, and usage analysis features. If you currently use Microsoft Office, you will find the toolbars, menus, and many other controls familiar.

Less expensive than FrontPage but not as friendly to use is HomeSite (Macromedia). It provides a lean, code-only editor for web development.

Macromedia's more powerful (and more expensive) Dreamweaver helps you create and manage websites and Internet applications. It is designed for rapid visual development but also includes extensive code-editing support.

If you plan to do e-commerce, check carefully for this functionality before purchasing a program or locking into a host. You can also purchase e-commerce software, such as eComm Store or StoreFront.

If you want to add virtual albums/galleries to your site, you'll need the deluxe or professional versions of programs, such as FlipAlbum or 3D-Album.

You can also create your own GIF animations if you use programs like the aptly named Advanced GIF Animator. And Macromedia authorware allows you to add rich-media e-learning functions, such as web-based tutorials and sophisticated simulations incorporating audio and video.

There are also numerous programs that add functionality or cool applications to your website. See Appendix A beginning on page 134 for more options.

http://

Preparing Photos, Video, & Memorabilia

In this chapter:

What Visuals Should I Include?

The visual elements you decide to include in your website are perhaps the single most important part of the whole project. Photographs are the most obvious visual elements to include: current snapshots, old pictures, and even historic ones.

Left: Virtually any print or flat artwork can be "digitized" for use on your website with an inexpensive flatbed scanner.

However, photos are certainly not the only visuals you can use. With a home scanner, you can also include memorabilia, such as ticket stubs, programs from wedding or funeral services, pressed flowers from a sentimental bouquet (see page 119 for an example), and much more.

Less is More

One good picture is worth far more than 10 adequate pictures. This is one of the hardest concepts for beginning photographers to understand. It is doubly true in the world of the Internet, where pictures translate into downloading time.

What Kind of Memorabilia Should I Use?

Take a few moments to think about the types of photographs and memorabilia you'd like to include on your family website.

PHOTOGRAPHS
- ❏ Family Snapshots
- ❏ School Portraits*
- ❏ Holiday Card Photos from Friends & Family
- ❏ Historic Family Photos
- ❏ Royalty-Free Photos

* You need permission to use copyrighted (©) photos. See sidebar on page 32.

ARTWORK
- ❏ Children's Drawings
- ❏ Paintings
- ❏ Doodles

OTHER ITEMS
- ❏ Handicrafts
- ❏ Fabric Swatches
- ❏ Jewelry
- ❏ Pressed Flowers
- ❏ Fresh Flowers & Garden Plants

VIDEO & AUDIO
- ❏ VHS, VHS-C, 8mm, Hi-8, or Digital Videos
- ❏ Historic family 16mm films
- ❏ Recordings of Recitals, Laughter, or Storytelling

MEMORABILIA
- ❏ Ticket Stubs
- ❏ Theater Programs
- ❏ Wedding & Funeral Announcements
- ❏ News Clippings
- ❏ Gift Cards
- ❏ Horse Show or 4-H Ribbons
- ❏ Merit Badges & Patches
- ❏ Boarding Passes
- ❏ Report Cards
- ❏ Certificates & Honors
- ❏ 3D Sentimental Objects
- ❏ Letters from Loved Ones
- ❏ College Acceptance Letters

The Editing Task

For professional photographers, editing their work is often a very painful and difficult process. They see good elements in many different pictures. The better the photographer, the more "winners" there will be per photo session. However, they too need to edit them down to just one single picture that best tells the story. To show four or five might dilute the best one.

Editing Criteria

The best photographs and other potential visuals for your website will meet all these criteria.

1. What is the goal of your website? Does this picture advance that goal?

2. Does the picture tell a story? Does it depict the subject as you want?

3. Is it well-composed and technically excellent (in focus, sharp, etc.)?

4. Is it a bold enough composition to hold up at a smaller size on the website?

5. Is it repetitive in subject matter compared to other pictures you have already chosen?

Edit Once, Edit Twice, Then Edit Again

Scrutinize your pictures and other Internet visuals carefully. Be brutal. If your site is junked up with so-so images, it will take a long time to download with little reward for the viewer who waited to see it. Two or three great photos from an event may leave a better overall impression than 20 adequate or repetitive photos.

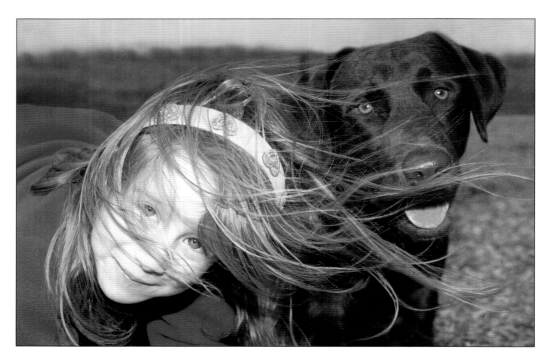

Left: A day of shooting pictures at the playground produced two rolls of film—but the whole story is told in one great shot.

Note also how the eyes of both the girl and the dog fall into the "Rule of Thirds" grid described on page 40.

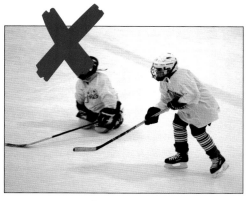

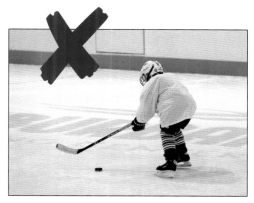

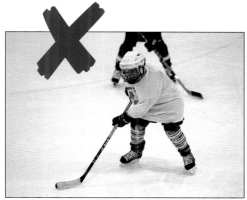

Right: It's hard to capture action, especially with a point-and-shoot camera. You may have to shoot a lot of pictures just to get one great image.

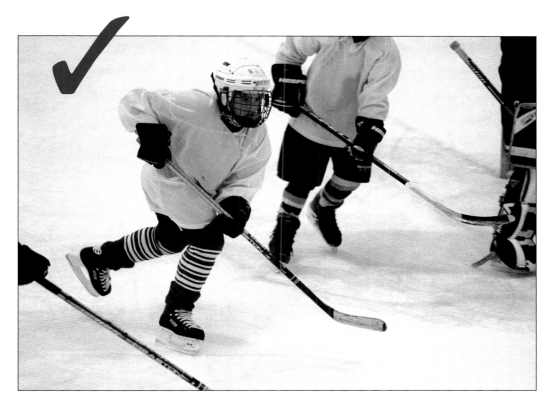

Keeping this in mind, pull out the best ones and put them aside. A few hours later go through this pile of good ones and weed out a few more. Then do it *again*! Unless they're well-trained at editing, few people can streamline their choices in just one swipe. Try to do it, however, because the end result will be much better.

Preparing Your Photos

Most family photographs are many shapes and sizes: prints, negatives, slides, Polaroid prints, historic tintypes, and modern digital pictures. The physical format determines what you must do to "digitize" a photo for your website. The chart on page 27 will give you a good start.

Your goal will be to change your prints or film into digital images, the format of the Internet. If you already have digital photographs from a digital camera or CD, you will still probably have to resize them for use on your website. See page 90 for more details.

Home Solutions

One of the quickest and least expensive ways to digitize your conventional photographs is to buy a home scanner and do it yourself.

1. Flatbed scanners are the most common type of home scanner. Low-priced models (under $100) are available, and most offer plug-and-play simplicity. You simply attach the scanner to your computer via a cord, install the manufacturer's software, and you can get good results right out of the box.

Scanners look like the top portion of an office copier. You lift the lid, place your print face down on the glass, and initiate the scan. Usually a scan window opens on your computer and "walks" you through the process. Most provide controls for cropping, sizing, color, and contrast. You click on "scan" and the machine goes to work. After a few seconds (or a few minutes for slow scanners or high-resolution images), the image pops up on your computer. Save it, and you have a digital version of your photo!

Flatbed scanners can be used for more than just prints. You can scan your children's drawings, your needlepoint designs, or any relatively two-dimensional object.

If you're careful not to scratch the glass, you can also scan 3D objects, such as fresh flowers, jewelry, stuffed animals, or merit badges. Try draping a dark cloth over the items to produce a dark background. Black velvet is the best because it absorbs light and will scan darker. If your objects are hard, moist, or have sharp edges, first lay a piece of clear acetate (such as blank overhead projector paper) on the glass to form a protective layer, then position our subjects.

Left: Affordable home scanners (such as this Microtek 6800) allow you to digitize flat objects, such as photos and drawings, as well as memorabilia including patches, ribbons, and jewelry.

Right: Film scanners (or flatbed scanners with transparency adapters) are needed to scan film negatives and slides. Shown at right is the Minolta Elite II.

"Digitizing" Your Memorabilia

FLATBED SCANNER
- ✓ Photos Sized No Larger than the Scanner's Maximum
- ✓ Tintypes & Historic Photos
- ✓ Drawings & Paintings
- ✓ Letters & Cards
- ✓ Newspaper Clippings
- ✓ Jewelry & Small, Flat Items
- ✓ Fabrics, Patches, & Needlepoint
- ✓ Flowers & other 3D Items

TRANSPARENCY ADAPTER FOR FLATBED
- ✓ Slides & Transparencies
- ✓ Overhead Projector Slides
- ✓ Stained Glass Ornaments

35mm FILM SCANNER
- ✓ Negative Strips
- ✓ 35mm Slides in 2x2 Mounts

APS SCANNER
- ✓ Advanced Photo System (APS) Films

PROFESSIONAL FILM SCANNER
- ✓ Other Film Formats

DIGITAL CAMERA
- ✓ Photograph Flat Items Larger than Flatbed Scanner
- ✓ Photograph 3D Sculptures & Items

PHOTO LAB OR OTHER VENDOR
- ✓ Everything You Don't Want to Do Yourself!

2. Transparency or film scanners are designed to shine light through a negative or slide to copy it (whereas a standard flatbed scanner does this by reflecting light off an opaque object).

Film scanners tend to be very high-resolution because the film is small in comparison to the prints made from it. They also tend to be high-resolution, high-end models, because professional photographers are the largest users of transparency films and need the highest quality achievable for reproduction of their work in books, magazines, and the like.

3. Some flatbed scanners have adapters that replace the normal scanner lid. This converts it into a transparency scanner for film. Though it probably won't give you enough resolution and quality for professional applications, it is a great way to convert those boxes of slides into digital pictures you can use on the Web.

4. All-in-one scanners usually combine flatbed scanning (for opaque objects) with film scanning, printing, photocopying capabilities, or any combination thereof. At the time of publication, there were several on the market that offered enough quality for all but high-end users. (Remember, for website usage, you only

Tips for Making Great Scans

OVERVIEW: Most modern home scanners come with software that opens a scanning control panel or "wizard" to walk you through the process. Once you open the box, plug the scanner into the computer (probably via a USB port), and load the software, you can probably start producing good scans. However, there a few ways you can improve your results with all but the most basic of scanners.

PREVIEW: The preview window will give you a quick, low-res view of the "scanning area". Don't take this for granted. Use the preview to get the image as close as possible to what you want. If you don't, you'll need to improve it later in photo editing software. This will take time and you may sacrifice quality. You're always better off starting as close as possible to the desired result.

STRAIGHTEN: Take the time to get your image straight on the glass, rather than rotating it later in photo editing software. Your quality will be better if you do it before scanning.

The only exception is when you're trying to reduce the patterns created when you scan newspapers, magazines, or books that were created from dot patterns as part of their reproduction process.

CROP: Why waste file space and scanning time by scanning more than you want? In the preview, you can usually adjust your cropping. Some scanners allow you to put several small items on the scanner, then crop and scan each item separately.

SIZE & SCALE: You can scan your print or negative at 100% size (no enlargement) at the ppi (pixels per inch) of choice. For web usage, select 75 or 100 ppi. For inkjet prints, select 150 to 250 ppi. For professional reproduction in magazines or books, select 300 ppi or higher. (See Glossary for more information on ppi.)

You can also make the scan larger or smaller than the original. For example, 200% enlargement will turn a 4x6 (10.2x15.2 cm) into an 8x12 (20.3x30.5 cm) at the ppi selected. Likewise, 50% enlargement will be half the original size.

IMAGE CONTROL: You may be given the choice of full-color, grayscale, or line art. Note that black-and-white photos are actually made up of many shades of gray. So if you wish to create a monochrome scan, click on grayscale.

If the image is truly black and white, such as a signature or a line drawing, select line art (and a high ppi). For photo-quality "black-and-white" images from color, simply select grayscale for your scans.

BRIGHTNESS & CONTRAST: The lightness or darkness of the print can be altered in the preview, as can the contrast. Contrast makes the blacks blacker, the whites whiter, and reduces the number of gray tones. A slight increase in contrast can increase the apparent sharpness of a slightly fuzzy original.

COLOR: Your original photograph may have an unwanted color cast, or may have faded over time, or the paper it is printed on may have faded to yellow. You can correct color casts in the preview for the most optimal scans.

You'll still probably have to make slight adjustments when you finish the scan, but even on the small preview screen you can probably get pretty close.

Near Right: Scanner preview windows (such as this one from an Agfa Scanwise scanner) appear on your computer monitor and walk you through the process. Some allow you to save time by scanning multiple objects at one time.

Far Right: A slightly cropped end result, prior to retouching.

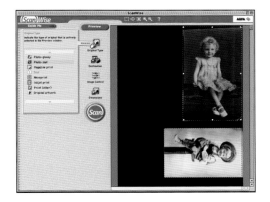

need low-resolution digital scans.) If you have many different needs, you might consider one of these units.

5. Advanced Photo System (APS) scanners are made specifically for the APS film cassettes. You insert the cassette into the scanner and it automatically scans the whole roll. This is great if you only shoot APS and have no older (pre-APS) pictures to include on your site. If not, you might be better off buying a flatbed unit and scanning your prints.

Vendors

If you don't want the bother of scanning the images yourself, or you only have a few images to scan, you can consider having them done professionally at your local photofinishing lab. Simply bring in a stack of prints, negatives, and slides, pay your money, and you'll get back a CD with digitized versions of the pictures. On future rolls that you shoot, you just check on the processing envelope that you want a CD as well as prints, and for an extra charge you receive both.

Popular online photofinishing companies include ofoto.com and shutterfly.com. You send them your film in a special mailer, and they send back your negatives and prints and then post digital versions of your pictures to a private album. The beauty of this online album is that you can select images to print, reprint, enlarge, frame, or turn into photo novelties. You can also email the link to family and friends, who in turn can order their own copies.

Online photofinishers don't provide one-hour or even one-day service, because you need to send in your exposed (but unprocessed) film by mail. But even so, it's fairly prompt service and saves you the scanning time.

You'll enjoy two major benefits: your family and friends receive the exact prints they want in the sizes they prefer, and the financial burden of numerous reprints is split because each party pays for their own prints, which are sent directly to their home.

Movies & Videos

Movie clips of your family can add a lot to a website if they are handled well. There are companies that will convert your old VHS, VHS-C, 8mm, and even Beta videos into digital form. There are also hardware/software kits like Dazzle that let you plug in your camcorder and "record"

it on your computer screen in digital form, just like a VCR. Digital video camcorders make the process easier because the footage is already computer-ready.

Don't forget the old family films on 8mm and 16mm film. Specialty vendors can convert them to VHS or transfer them directly to digital. If you have trouble finding a vendor, call up one of your local wedding videographers. They often include historic footage in wedding or reunion videos and may be able to point you in the right direction.

Once your footage is digitized, viewers of your site may then view the movies by using a "player" like Microsoft Windows Media Player or RealPlayer. Some sort of player is usually included

Video Files

Regardless of how you get your video digitized, you'll want pay attention to file size and file type. Both video and films are created by putting together enough sequential still photos that the mind is tricked into seeing fluid motion. Usually this is about 30 frames per second (fps) for videos. But on the Internet, you will still get acceptable results at 10 to 15 frames per second, though action and zooming might look a little jumpy.

Because movies are made up of many still pictures, they can quickly make large files. They must be compressed (encoded) into an Internet-friendly format, such as MOV, AVI, WAV, MPG, or WMV.

The "screen size" will also make a difference, from smaller (but faster-loading) thumbnail 120x90 or 176x144 sizes up to larger and easier-to-view 480x640.

Below: You can have your 16mm and other historic film footage digitized to create still pictures or "video" clips that can be displayed or shown on your website.

You Must Edit Your Video Clips

Pretend you're just picking out the highlights for a news broadcast!

Let's face it. All those hours and hours of video that you have are for the most part very boring. The trick is finding the very best short segments and editing out the rest. Think in seconds rather than minutes.

Use a stopwatch while you watch the sports portion of the evening news and you'll be amazed at how short the highlights actually are. Yet they tell the story much better than two or three meandering minutes of less powerful footage.

Don't do one long movie called, "Our Sports Stars." Instead, spend some time editing and make separate, short pieces like "Soccer Final Highlights," "Rob's First Home Run," and more. Not only will they be easier and faster for people to download, but you'll avoid the yawns that are traditionally associated with home movies.

DIGITAL VIDEO (DV): If your video is digital already (from a digital camcorder or a digital camera that can shoot "movie clips") you can invest in editing software that will help you cut, splice, and segue the footage, or add "Hollywood" effects. Then the software can "encode" it into a small-sized, Internet-friendly format.

CONVENTIONAL VIDEO: VHS, VHS-C, 8mm, Hi-8, Beta, and other "analog" video formats will need to be digitized by a vendor or by means of a hardware/software combination that hooks your camcorder or VCR to the computer.

OLD 16mm & OTHER FILM: Many service vendors can "digitize" your historic film footage. It's up to you to edit it after that!

with the operating system on new computers, but you can also download them for free from the manufacturer's website.

A few hosts allow "real-time" streaming video. This is nice because the host server parses out the video so it can be viewed without the visitor having to download it to a computer to view it.

Many digital cameras have a video or movie function that allows you to record a short, live-action clip that runs from a few seconds to a full minute. High-end models produce smooth movies, sometimes with sound. Low-end models are silent and choppy like an old 1920's silent film. But both are a lot of fun!

These movies are often in a computer-ready format such as QuickTime.mov, and can be easily added to your website. Software is required if you want to edit or shorten them.

Copyright

Just because you are able to scan it, that doesn't mean you can legally use it! Most professional wedding, school, and portrait photographs are protected by copyright, meaning you cannot reproduce them without permission of the photographer.

Most photos and artwork printed in magazines, books, brochures, or the newspaper are covered by the same copyright laws. If the image or text has a © symbol near it, then it is definitely copyrighted. Even if it doesn't, it may still be covered so you may not display, distribute, or sell it without permission.

This includes portrait and wedding photography! On the positive side, most wedding and portrait studios will gladly give you permission to show the images on a personal (noncommercial) website, especially if you credit them. After all, that is free advertising!

Assume it's copyrighted!

Most people get email chain letters with funny or interesting pictures attached. Just because it arrived free in your mail server doesn't mean it is copyright-free.

The original person who attached it (perhaps 50 or more email generations earlier) might have unknowingly or purposefully broken copyright laws by copying and distributing it.

Be careful with your text, too. You can't copyright an idea *per se*, but exact words are sacred. You don't want to plagiarize a writer. When in doubt, you should thoroughly accredit any writing you have "borrowed" and ask permission before posting it. Most people are glad to have the extra publicity showing up on multiple websites.

Protect Your Copyright

Just as you don't want to infringe on anyone's copyright, you don't want your words and pictures stolen! You can "watermark" your pictures with a © symbol (see photo above), but this is ugly and time-consuming.

Free JavaScript Applets are available to keep the casual viewer from copying your materials (advanced folks can get around it). WebSource.net offers a free cut-and-paste script that will prevent users from using the right-click on a PC mouse to save the picture. Instead, an alert box will appear with your copyright or other notice.

If you can, check that the © symbol shows up correctly on Mac and PC computers, as well as in different Internet browsers. If it doesn't, you may be better off using a Graphics Interchange Format (GIF) of the symbol, or using parentheses around the letter "C," as in (c).

Sourcing Off the Internet

If you don't have the right image in your files, you may be able to find it on the Internet. Although you can physically copy photographs off other people's websites, you do not have the legal right to use them on your website unless you get permission from the photographer. The exceptions are photographs in the public domain, such as U.S. government images.

Likewise, mass emails of funny or cute photographs tend to blaze across cyberspace reaching thousands, hundreds of thousands, or even millions of people. In the process, the source of these photos can be lost. The first person in the chain may have copied the image illegally or unknowingly borrowed it. It is always best if you source the image yourself. Then you know for sure if it is royalty-free or copyright-free.

Microsoft WordArt

You can create fancy type for your website with Microsoft Word utilizing the "WordArt" toolbar (accessed through the VIEW/TOOLBAR commands).

Clip Art Photos

If you don't have the right image in your pile of snapshots, you can search for royalty-free and copyright-free photographs to use. Copyright laws protect the rights of photographers by making it illegal to use their photographs without buying them or paying for the right to use them.

However, you can use clip art and photos that are copyright-free. They are available for purchase in the form of CDs or Internet downloads. Office supply and computer stores usually offer massive collections of clip art illustrations and photographs for a reasonable price.

Free photos and clip art are also available from a number of online sources. See the Resources Appendix on page 134 for links.

Right: FEMA (the Federal Emergency Management Agency) maintains an online photo library that has a searchable database of photographs.

Picture-Taking Tips

Best Portraiture Tip

My favorite portraiture trick (and perhaps the easiest to learn and follow through on) is simple. Determine your subject's eye level and raise or lower yourself to get on the same level.

Most folks shoot at their own eye level and rarely get down to their children's levels. Try getting on your belly with the baby, on your knees with the toddler, or standing tippy-toe to reach the eye level of your teenage son.

It may sound simple, but it really works. For starters, you avoid the distortions you'd get if you had to look down at a youngster or a pet. Secondly, eye-to-eye contact feels intimate in the real world, so why wouldn't it also be so in photography?

Candids

Some of the most successful photographs of people, especially children, are taken when the subject isn't paying attention to you and your camera.

Portraits of the family smiling at the camera are fine, and a traditional portrait is certainly an important part of your family archive of photographs. However, consider taking more candid pictures to add variety.

This starts by remembering to carry your camera with you on a regular basis. You just never know when your kids are going to start doing something fun or interesting. When they do, just casually take out your camera and take the photograph inconspicuously.

Left: Get down to your child's eye level to get a more intimate portrait.

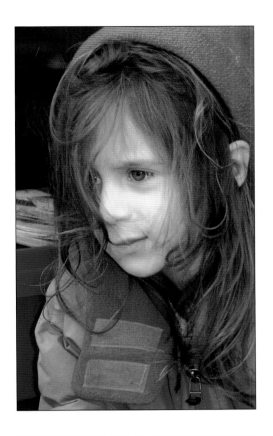

Right: Use candid techniques to catch natural expressions on your children's faces—instead of just the "Say cheese!" photo smile.

Memories Are More than Just Smiles

No two kids are alike, and one sibling might be described as "very quiet, serious," or even "moody," while another is unquestionably a jokester.

You might find that the most memorable photographs are not of your child's forced smile that comes from saying, "Cheese," but rather the expressions that reflect the child's true personality.

Digital cameras have the advantage of their monitors, so you can compose the picture surreptitiously without having to bring the camera to your eye.

To be even more discreet, do this at a distance with the camera zoomed all the way to the telephoto ("T" or "tele") setting.

Group Portraits

Photographing a group of people is actually a difficult thing to do well. For starters, just shooting everyone smiling and with their eyes open can be tough. The only assurance is to take a LOT of pictures and hope for the best (or be prepared to do some computer magic and replace a frowning face with the smiling version on a different exposure).

Beyond that, the key is to get creative with the posing. Usually, your first instinct will be to line up the group shoulder to shoulder for the picture. This is rarely the best composition, and you end up with a picture that looks like a police lineup.

The easiest posing tip is to try and put the heads at different heights. This makes the composition more dynamic. It also has the added bonus of tightening the group so you can move or zoom in closer to make the faces larger.

The simplest way to do this is to make several rows, with the front line sitting, kneeling, or even lying down! Seat the parent (or an especially tall or short individual) so they do not stick out from the group.

Avoid Lineups!

Avoid the traditional "police lineup" by posing your group so that the heads of the subjects (both humans and pets) are placed at different levels.

Here, the heads of mom, the two kids, and Emmitt and Dixie form a circle rather than a straight line.

Another method for posing a group is to use a staircase to put people at different heights so everyone's face is fully visible in the picture. Or look for a picnic table or rock formation to pose everyone on and around.

Portrait Mode

Some cameras cameras offer a "Portrait" exposure mode, which, not surprisingly, is a great choice for portraits. This mode tells the camera to select wide apertures, thereby throwing the

Left: Portrait Mode alters the aperture on the camera, causing the background to be more out of focus (and thereby less distracting).

Right: Some cameras offer advanced exposure modes that help you get better results with certain types of subjects. These modes may include Close-Up (top right), Scenic or Landscape (middle right), Action (bottom right), and Portrait (page 36).

background out of focus in many situations. An out-of-focus background tends to be most attractive in portraiture because it eliminates distractions in the background that would take away from the impact of the main subject.

Other Exposure Modes

Some high-end cameras offer other exposure modes that weight the camera for certain types of subjects.

Program (P) Mode is the automatic mode of the camera. It will weight the camera controls for the average subject.

Most landscape photographers want their images to be sharp and in focus from foreground to background. Landscape Mode helps by optimizing the camera toward this goal. This is a great choice if the scene has interesting foreground and background elements, such as the canoeists and the distant mountain shown at center right.

Action Mode sets the camera so that the shutter speed is as fast as possible for the given film or equivalent ISO in a digital camera. This will result in the sharpest (least blurred) result. For more action tips, see page 124.

Macro or Close-Up Mode, usually depicted by a flower icon, optimizes the camera for shooting small subjects up close.

Aperture (A) Mode and Shutter (S or T) Mode enable photographers to select the aperture (f-stop) or shutter speed of their choice.

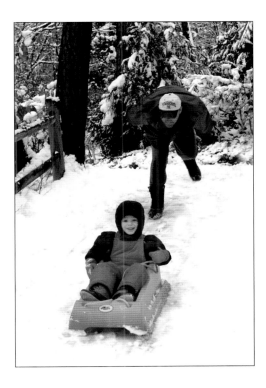

Remove the Clutter

You clean up your house (or you try to!), so why not "clean up" your photos too? Perhaps the most important compositional tip is to simplify the picture. Try to minimize background clutter and avoid distracting elements. Look for bright colors or reflective objects that might prove to be especially distracting.

Bright colors like red or yellow, letters in signs or billboards, or reflections can be very distracting and draw your attention away from the main subject. Vertical lines, such as trees and light poles, have an annoying habit of "growing" out of your subject's head.

Often you can avoid all of these problems by performing one of these actions:

1. Move the camera position to the right or left (or up, down, or both) so the background changes in relation to the subject.

2. Move the subject so they are standing against a less cluttered background.

3. Zoom in (or step closer) to fill more of the frame with the subject, thereby eliminating the background.

4. Use photo-editing software to retouch a cluttered background or remove a distracting object.

5. Use photo-editing software to crop the image so that the subject is more prominent and the background is no longer part of the image.

Below, Left to Right: One way to reduce the clutter is through using software after you take the picture. First, retouch the background to simplify it, then crop in on the main subject.

Near Right: Looking
down on your subject
tends to make the
head look too large.

Far Right: Shooting
from a close range
with a wide-angle
lens tends to cause
distortions.

Below: The most
attractive pet (or
person) portraits are
usually achieved by
stepping back and,
zooming the lens
to the Tele or
"T" setting.

Step Back & Zoom In

When you shoot portraits with a wide-angle lens, there is often an unpleasant distortion. You might not *realize* that there is a distortion, but the result will seem less complementary and even "fat." The closer you get to the subject and the wider the lens, the worse it looks. Note how the dog's head looks large in the two smaller pictures on this page.

Instead, step back and zoom all the way out to the telephoto ("Tele" or "T") setting. Then step backward until you have the composition you want. Usually for portraits, this means a head-and-shoulders picture. If space is limited, do the best you can.

Skip Digital Zoom

If you're shooting with a digital camera, turn off the digital zoom function. Instead, use the camera's optical zoom if it has one. The reason is that digital zoom greatly reduces the quality by simply cropping the picture in camera before it saves it. You're better off cropping it later, using image-editing software.

Place the Subject Off Center

For most people, the instinct is to center your subject in the center of the viewfinder like a bull's eye. However, this is rarely the best way to design the photograph. A handy guideline called the Rule of Thirds can help you improve your pictures.

The idea behind the Rule of Thirds is to divide your picture into three equal sections both vertically and horizontally, as shown below in red. The intersection points of these lines (as well as the lines themselves) become the "hot spots" where you want to place important picture elements.

In the comparison shown on this page, both the person and the horizon line

(where sky and water or rock and beach meet) are important. In the bottom version, the person has been moved to the left third, and the horizon has been dropped down to the bottom third. This yields a far more successful result than the first version.

Below: The Rule of Thirds is demonstrated, with the best (and off-center) version on the bottom.

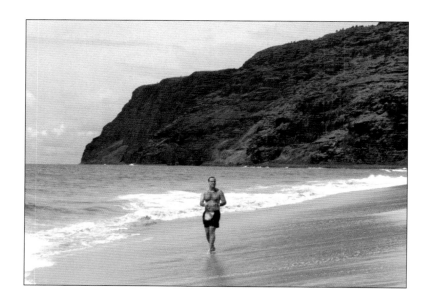

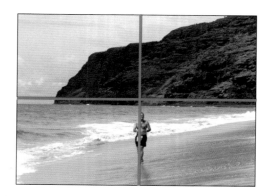

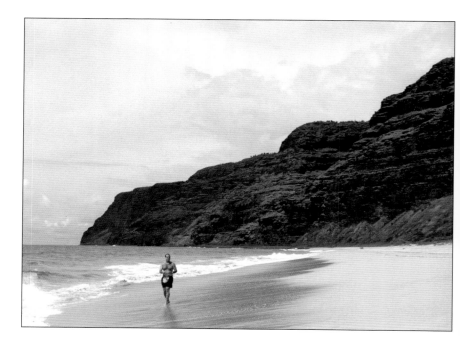

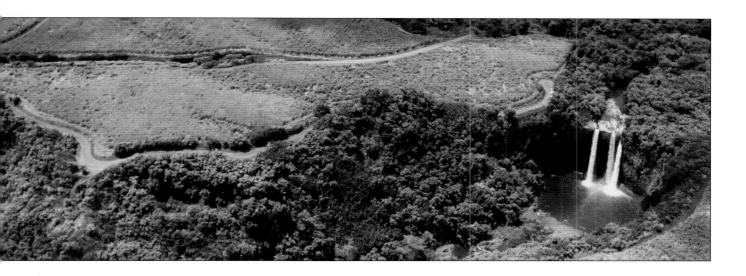

Above: Even extra-wide panoramic (P) format images are subject to the Rule of Thirds.

Note that since these lines divide the picture evenly, the shapes they create change for the different picture formats. 35mm film cameras have the aspect ratio of a 4x6 print. Panoramic format prints are extra-long, usually in the 4x10-inch format. The Rule of Thirds still applies, as can be seen in the double waterfall aerial photo above (shot in Kauai, Hawaii). Here, the waterfalls are placed in the upper right third of the picture area.

This rule is meant to be a guideline, and many times it can be broken successfully—but more often than not, it works. Experienced photographers often take it to further extremes, placing subjects even farther away from the center of the frame than the guideline of one-third.

The Horizon

Don't get so caught up in the beauty of your scenic picture that you forget about the horizon line. Make sure the horizon is straight. It's easy to accidentally hold the camera a little crooked, especially if you're looking through a digital camera's monitor. Don't fret too much. You can correct a crooked horizon in the computer later by rotating the image.

Also, be aware of where your horizon is in relation to your subject. It can be sometimes be distracting if it cuts through the main subject. often the best compositions place the horizon in the lower or upper third of the image.

Turn the Camera

It feels most natural to hold your camera horizontally as it was designed, but some subjects are better if shot vertically. Consider turning the camera sideways if your subject is taller than it is wide. This includes people, trees, a sitting cat, and some waterfalls. Mixing horizontals and verticals on your website will add a nice visual variety.

It is important to note that the Rule of Thirds can apply equally well to horizontal and vertical compositions.

Play the Angles!

If I were to guess, I'd say that 99.9% of the snapshots taken in this world are done from the photographer's eye level while standing. And I'd follow that up with the guess that more than half of these pictures could be improved by changing that shooting angle!

Since we spend our lives seeing the world from our own eye level, you can

really shake things up by getting really low or high to shoot a picture. Try lying on the ground or shooting down from a balcony. And when everyone else is looking straight ahead, try looking up or down.

You can exaggerate your new perspective by coming in close with a wide-angle lens or zooming in from afar with a telephoto lens.

You can even take the high angle to extremes by shooting aerial photos during a scenic airplane or helicopter tour.

Bad Weather

Sunny days are great for bold landscape pictures, especially when you use the dark shadows for compositional impact.

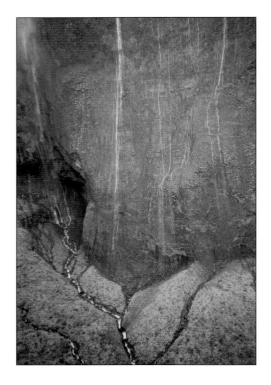

Far Right: Colorful backgrounds can help to frame a subject. But be careful! Abrupt color, such as a red stop sign, can be very distracting.

Far Left: Good photographers know that many of the best images are not taken from "eye level." Look up and look down, or get to a high or low vantage point.

Left: The highest angle of all is an aerial photograph. Plan a scenic flight on your next vacation!

Right: Rainy, snowy, and overcast days can be great for both landscapes and portraits.

However, "bad" weather can also yield great results. Cloud cover creates soft, complementary lighting that is great for portraits and flowers. Storms, snow, and other "bad" weather can yield dramatic photographs.

Moods & Colors

Many colors are attributed with certain moods. In the same way you select your background and text colors for your website, the colors in your picture can have an effect on the overall photograph.

Most people perceive colors in the following ways:

● ● **BLUES & SOME GREENS:** These tones usually make the photo feel cool.
● ● **REDS, ORANGES, & YELLOWS:** These tones communicate warmth.

○ **WHITES:** White tones reflect innocence (think babies and brides).
● **BLACKS:** Predominantly black pictures are usually very dramatic
● ● **CONFLICTING COLORS:** They can give a disconcerting feel.
● ● **HARMONIOUS COLORS:** These pictures tend to feel more relaxing.

Good Color, Bad Color

Our eye is naturally drawn to bright colors like reds, yellows, and bright blues. These colors can attract our eye to a photograph. A flower in the hair of a little girl can add a brightness and playful mood to a picture, or a bright red hat can frame a person's face.

On the flip side, these same colors can have a negative impact on your picture. For instance, a bright red stop sign in the background, or a bright reflection off a metal can or window pane, could draw the viewers' eyes away from your all-important subject.

Understanding Flash

Most point-and-shoot cameras have a small, built-in flash. The simplest cameras require that you manually pop up the flash when you want to use it, while other cameras fire the flash in dim light situations (using a mode called AutoFlash). Higher-end cameras provide different flash modes for specialized shooting situations, including Flash Off.

1. Flash Range

The small, built-in flash on most point-and-shoot cameras is not very powerful. It is important to understand the limitations of this flash in terms of the range within which it works well. If you are too close (a few feet), then the subject may be too brightly lit because the camera can't reduce the flash's output enough. If you are too far away, then it cannot reach far enough to illuminate the subject and the subject will be dark. Check your instruction manual for the flash range on your camera. It changes, depending on the ISO of the film you are using (or the equivalent ISO on a digital camera). Usually the safe distance is about 6 to 15 feet (1.8 to 4.5 m) with ISO 100.

Turn off the Monitor

If you are worried about the battery life of your digital camera, turn off the monitor and use the viewfinder instead. The little monitor on the camera eats up the lion's share of the power. This will leave more power for other camera functions.

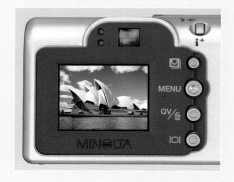

2. Recycle times

Flash requires a lot of battery power, and it can sometimes take a few seconds for the flash to recycle. Depending on the camera, the camera may refuse to shoot again until the flash is ready, or it may take the picture anyway at less than full power (probably resulting in a subject that is too dark). Check your instruction manual so you'll know when it is safe to shoot again.

3. Fresh Batteries

If your batteries are getting weak, the camera may still be able to take pictures but not have enough strength to fully power the flash. This could be the case

Left: Built-in flash units are not very strong and cannot illuminate a distant background. This could result in "floating heads" on a pitch-black background.

even though the "low battery" symbol might not yet be showing.

4. Turn Off Red-Eye

Red-eye is that annoying "devilish" red color that fills the eyes of some people in flash pictures. Red-Eye Reduction Flash mode causes a bright lamp or series of flashes to go off before you actually take pictures, reducing this effect.

Unfortunately, this can be annoying and cause a delay before the picture is taken. The frequent result is that your subjects will have a startled look or will have already looked away because they thought the pre-flash was the picture moment.

Instead, you can risk producing the red-eye effect, and then improve it in the computer later. You'll be bringing your pictures onto the computer to prep them for your website, so why not use the easy red-eye repair functions? They're found in inexpensive photo-editing software, such as Picture IT or PhotoSuite.

5. Fill Flash

Fill flash is the quickest way to make significant improvements in many of your outdoor pictures. In bright, sunny situations, the sun can cause deep shadows on the faces of your subjects that hide their features—or worse, these shadows can emphasize wrinkles.

The auto-flash feature on most cameras fire when the lighting gets dim. Fill flash, on the other hand, forces the flash to fire even in bright situations. The flash then fills the shadow without having a major effect on the main light (the sun).

Right: While taking portraits on a sunny day, select Fill Flash Mode to lighten shadows on your subject's face.

It also adds attractive highlights to your subject's eyes. Because this feature makes such a significant improvement in your pictures, when in doubt, use it!

5. Night Flash

Occasionally, you will want to take a back-lit or nighttime portrait with an interesting background, such as city lights or the last glimmer of a sunset.

If your camera has Night Flash Mode (sometimes called slow sync flash), this is a good time to use it. Night Flash Mode combines a flash exposure (which illuminates a nearby subject) with a longer shutter speed (which enables the surrounding background to record as well). In the example shown below, the flash illuminated the two people while the longer shutter speed recorded the twilight scene.

For optimal results, steady the camera with a tripod or brace it against a solid object to keep the background sharp.

6. Flash Off

Most cameras will automatically fire the flash if the light is dim (Auto Flash Mode). Sometimes natural lighting can be wonderful by itself, such as at dawn or dusk, and you may want to overrule the camera's setting and turn the flash off. Usually this flash mode is indicated by an icon with a lighting bolt symbol and the "no" circle-and-slash symbol around it.

If you choose Flash Off in low-light or dimmer lighting situations, your camera will be using a relatively slow shutter speed. This can cause the picture to be blurred unless you steady the camera. You can do this by using a full-size or tabletop tripod,

Left: Night Flash is a good choice for combining a flash exposure for a backlit subject with a long shutter speed to record the twilight background.

Right, Center, & Lower Left: Three examples of good situations for Flash Off include sunsets, fireworks, and creative blurs.

Far Lower Right: An SLR camera (a Minolta Maxxum is shown here) and some high-end point-and-shoot cameras can accept powerful accessory flash units.

bracing it on a steady object, or snuggling it in a coat or towel. Switching to a higher ISO film (a "faster" film) or a higher equivalent ISO on your digital camera will also help you get sharper results.

Flash Off can also be used for fireworks. Even though you're in the dark, you're actually photographing light (the firework explosion). Since you can't illuminate light, you should set the camera to Flash Off.

Flash Off is also useful in situations where flash is not allowed, such as the theater, weddings, and museums.

7. Accessory Flash

Most SLR cameras (see picture) can accept an accessory flash. These tend to be more powerful and more adjustable. You can illuminate more distant subjects, properly light close-up subjects, and bounce or diffuse the light for good portraiture lighting.

Improving Images in Software

Today's picture-editing software makes it easy to quickly improve your pictures. Many computers, digital cameras, and printers come bundled with simple picture-editing software. You can also buy many excellent programs for under $100.

Magazines such as *PCPhoto* and websites such as http://www.pcworld.com often run reviews that will give you more information and hands-on opinions. Check the websites of the software in the Resources Appendix (page 134). The homepages for these software programs may offer demos of their programs or even downloadable trials. Some of the more popular choices are mentioned below.

Adobe Photoshop & Photoshop Elements

Photoshop sets the professional image-editing standard. It allows you to work more efficiently, explore new creative options, and produce the highest-quality images for print, publications, and anywhere else. Its disadvantages are that it is quite expensive and it has a huge learning curve.

Photoshop Elements is a powerful yet easy-to-use version of Photoshop. You can edit and enhance your photographs with special effects or quickly create animations for your website. From quick corrections to creative editing, you can easily achieve high-quality results. I particularly like its VARIATIONS option for quick color correction.

MGI PhotoSuite

PhotoSuite 4 Platinum allows you to capture, organize, edit, and share your digital photos. Arrange your photos into electronic albums, and then tweak them with over 40 powerful editing tools; create seamless panoramas by stitching up to 48 photos together; or choose from more than 1,000 professionally designed project templates for home and business projects.

Far Left: You can have a lot of fun using photo-editing software to improve or completely alter your photographs.

It has web building tools, complete with graphics, audio, interactive panoramas, animated photos, and links.

Microsoft Picture It

The powerful photo-editing tools and built-in wizards in Picture It Photo Premium make it easy for everyone to improve their photos. You can produce the highest-quality results so your photos look their best to share in prints, email, and the Web. Included is a wide selection of high-quality project templates for photo cards, calendars, labels, flyers, and more.

The software includes 1,500 templates for photo cards, frames, calendars, trading cards, magazine covers, web photo albums, and other photo projects.

Scansoft PhotoFactory

PhotoFactory actually combines three software packages: PhotoSoap, SuperGoo, and Power Show. PhotoSoap provides you with professional photo retouching tools and allows you to export pages ready for the Web. Power Show enables you to create and play home photo shows or enhance business presentations.

SuperGoo is a manipulation program that allows even young kids to liquefy, stretch, twist, warp, and smear an image using a library of customizable Liquid Image distortion tools—all in real time. (See page 57 for an example.)

Ulead PhotoImpact

PhotoImpact combines photo-editing and graphics software in one easy-to-use package. It takes the user through every step of the way, from transferring and organizing photos to enhancing and sharing images.

You can easily manage and enhance digital photos and produce high-impact web pages for recreational or professional use. Logos and other graphics can be created with advanced text and 3D features. Or, you can produce original works of art with a full set of painting and drawing tools.

PhotoImpact features both automatic commands for quick solutions and elaborate tools for detailed photo adjustments. A nice feature is the ability to record a set of editing tasks and then apply them to individual or grouped photos.

What Can Be Improved?

Photo-editing software gives you incredible control over your digital pictures. You can alter the pictures in "traditional" ways by using controls such as cropping, enlarging, dodging/burning, and brightness. You can also change your images in "new" digital ways, such as adding artistic blurs, combining two photos, morphing and "goo-ing," and distortions of all types.

Cropping

The quickest way to improve your photographs is to crop out unimportant visual information. You'll be amazed how quickly trimming off the edges can improve the image by drawing attention to the subject.

You can also use cropping to eliminate bad or boring backgrounds or to turn a horizontal into a vertical!

Below: 1) An antique, damaged photo; 2) changed to B&W to eliminate stain; 3) converted to brown duotone; 4) type and clip art pumpkin added; 5) more art added; and 6) border added.

Add Text

Most photo-editing programs will let you add text to your photograph. You can place the text on top of the photo in black or another color, or knock it out in white. Some programs let you cut out the type so another photo can show through from beneath.

Right: Type can be black, white, colored, or knocked out of the background. It can also be skewed or stacked vertically.

Colored Type
White Type
Opacity 50%
Black Text
Opacity 50%
VERTICAL
SKEWED

Below: Photo-editing software and plug-in programs offer countless borders and edges you can add to your photographs.

Edges & Borders

A picture placed on your wall that is in a carefully chosen frame and a well-made mat can look stunning. Do it right, and you can enhance the picture. Do it wrong, and the frame becomes more important than the picture and robs it of impact.

Frames on photos are also important in the Internet world—but here we'll call them EDGES or BORDERS to avoid confusion with the design construction term FRAME.

Selecting the right border is easy in photo-editing software because you can compare different effects and pick which works the best for you. The frame then becomes a part of the picture and visible when you import it into your web design.

Blur

There are many different types of blurs. Some are for obvious special effects, such as the "speed" blur that leaves a blur behind the subject to communicate the concept of speed. Others can be used to correct problems, like when you scan something with a dot pattern, such as an art plate from an old book. You can tilt the picture by two or three degrees, apply Gaussian Blur, restraighten it, and sharpen it. This will sometimes help to reduce the appearance of the dots.

Red-Eye Correction

Everyone has seen this annoying problem in photographs of people, especially when taken with point-and-shoot cameras. The Red-Eye Reduction Flash mode on some cameras will reduce it, but many people find the pre-flash strobe or lamp and the delay it causes to be annoying. Instead, many photo-editing programs, such as PhotoSuite and Picture IT, have simple red-eye functions that enable you to click on the eyes in the subject to quickly and automatically neutralize the red coloring.

Sharpen

The Sharpen tool cannot work miracles, but it can help to improve the appearance of slightly unsharp images. Be careful to use a light hand, because overly sharpened pictures get a grainy, fake look. Increasing the CONTRAST can also help create the appearance of sharpness.

Layers

Layers are the big advance in photo editing programs in the past few years.

Below: Correcting red-eye is a simple task in programs ike Microsoft Picture IT. This program allows you to enlarge the image and click on the red eyes, and it automatically corrects the image.

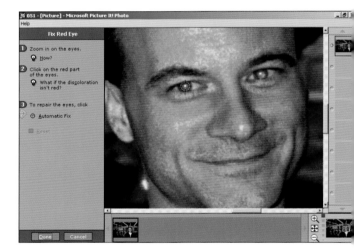

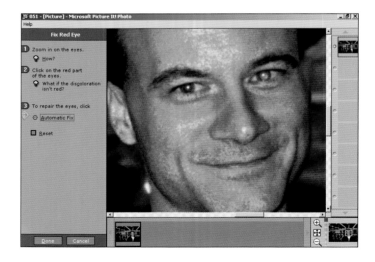

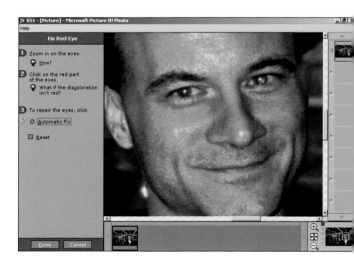

Layer 1

Layer 2

Layer 3

Layers 3, 2, 1

Layers 2, 3, 1

Layers 1, 2, 3

It allows you to create layers made up of different photos, type, graphics, and more. These layers can be transparent or opaque, and their order can be changed. The beauty is that they allow you to work on and move around separate parts of the artwork without affecting the separate layers.

If a top layer has a cutout section (or is a silhouette), the layer beneath will shine through. Advanced programs let you change the opacity of the layer, so you can put a faint, almost transparent photo over another layer. In the example above, three different ways of stacking the layers (from top to bottom) are shown.

Erase

You can erase a portion of the image with this handy tool. One of its best uses is with special effects, such as BLUR and TRANSFORM. You start by making a copy of the picture on a separate layer, apply the effect, and then erase most of it so the

unaltered image shows through (except for a few places). An example is turning your kid into a superhero by erasing a directional blur from all but his backside, which creates sense of motion.

Brightness & Contrast

You can quickly improve a picture by brightening or darkening it overall with the brightness control. You can also increase or decrease the contrast. Increasing the contrast makes the shadows darker and the highlights lighter.

Dodge & Burn

The overall brightness control in most programs affects the entire image. However, there will be times that you want to lighten or darken only particular parts of the picture. For example, you can DODGE a face to lighten it, or BURN a background object to make it darker and less distracting.

For the best results, adjust the size of the dodge or burn tool (usually by selecting the right-sized BRUSH). Then, select the OPACITY at a low number. It is better to take several strokes at 10%

opacity than one strong stroke at 100%. It takes more time to get to the lightened or darkened effect that you want, but the result will be smoother and more natural looking.

Color Correction

It is not uncommon for your photograph to have an unwanted color cast. You may not even realize it has one until you see a corrected or improved version.

Adobe Photoshop Elements software offers a quick way to check by using the VARIATIONS command. First, it shows your original, then versions with more red, green, blue, cyan, yellow, and magenta, as well as lighter or darker versions. Click on the one you like best and you're ready to go. Other software has sliding bars you can move to adjust the color.

Below: Brightness and contrast controls can quickly improve an image. Try the AUTO LEVELS first, but don't hesitate to use the UNDO function if they go too far. Then, adjust the levels manually.

Right: The nearest photo was very cute but the faces were too dark. If the overall brightness had been increased, the rest of the scene would have become too light. Instead, the DODGE tool was used to brighten just the faces and clothing.

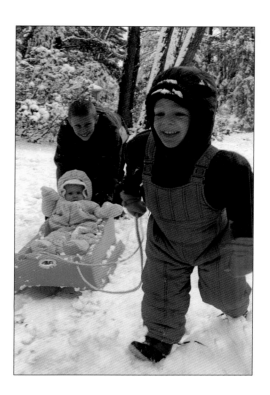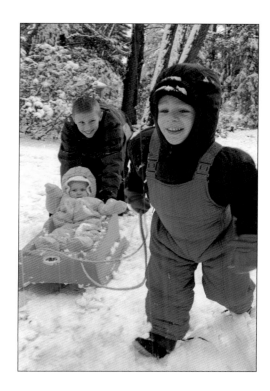

Right: Historic photos, such as this slide from 1961, can pick up color casts from age. These can be corrected with photo-editing software.

Color casts can also be a problem in modern pictures. Overcast skies, indoor lighting, extremely long exposures, reflections off colored walls and ceilings, poor film processing, and other factors can cause a picture to have an unpleasant color cast.

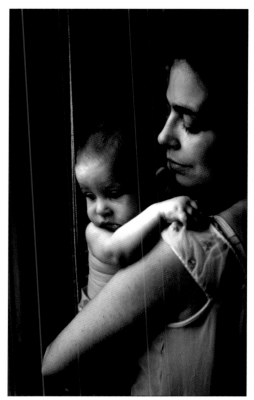

Quick Fixes

Most photo software programs offer an AUTO LEVELS or similarly named function that will automatically correct the color, contrast, and other aspects of your digital photograph. For example, snow scenes are usually underexposed because the camera is fooled by the whiteness of the scene, and as a result the snow picks up an ugly bluish cast. The AUTO LEVEL control will usually remove this cast for you. If the program has a "preview" option, you will be able to see the suggested changes before committing to them.

This auto program doesn't always improve the image, and it often takes it too far. So more often than not, you'll have the best results if you do it manually.

Color Modes

You can instantly change your color picture into black and white, sepia, posterized, super-saturated, duotone, and more. (See the samples below.) Be sure to give the new version a different name *before*

saving it, or the original color information will be forever lost. Note that when most people say, "black-and-white photograph," they really mean a photo made up of shades of gray (grayscale).

Stamp or Clone

This is one of the most important tools to learn if you want to quickly retouch your pictures. The concept is that you "rubber-stamp" the picture by picking up "ink" (another portion of the picture) and stamping it down elsewhere. You can quickly remove a facial blemish in a portrait, clear out trash from a background, or simplify the background. Random textured areas, such as grass or bushes, are often the easiest to work with.

Rotating Your Image

Earlier in this chapter, we showed how vertical images can be very powerful compositions. Unfortunately, when you download the image to your computer, it will be displayed on your monitor sideways.

Below: You can choose different color modes to give your image a different feel. Some digital cameras allow you to select color mode options on the fly, or you can make these changes later in photo-editing software.

Color **Saturated** **B&W** **Sepia**

tools described in this chapter and repair it with the CLONE, STAMP, and CONTRAST tools, among others.

Above: Old, damaged, or faded photos can be repaired with photo editing software. Some scanners now have software that automatically does this. You can also do it manually in photo-editing software, using the STAMP and CLONE tools.

You'll need to rotate the image to view it properly. In addition to quarter turns (90° and 270°) or half turns (180°), you can select ARBITRARY ROTATION to straighten an image if you accidentally take it slightly off-kilter.

Restoration

A photo that has been damaged from age or rough handling can be digitally fixed as well. Amazing new technology in some scanners will automatically correct and repair scratches and dust. Simple software programs can automatically recolor faded pictures or retouch creased pictures. Or, you can use the

Paintbrush

If you're feeling painterly, you can also "paint over" the photograph. Programs such as Microsoft Picture IT give you numerous choices in brushes, from an airbrush effect, to different types of strokes, and even to repetitive patterns that mimic wallpaper borders.

Artistic Enhancements

There are numerous other artistic enhancements that include tracing, texturizing, smudging, collaging, tracing, stretching, "goo-ing," morphing, and many other creative options. Let your imagination go wild!

Graphics Software

In addition to photo software, there are graphics software packages that meld illustration with photography. Popular software includes Adobe Illustrator and Deneba's Canvas. These offer advanced illustration functions and the ability to create vector art. They're great for making special graphics for headlines and logos.

Right: Kai's Super Goo is a fun program for both adults and kids. With a single drag with a mouse, you can smush, stretch, and morph your picture.

Chapter 3

Ingredients in a Website

In this chapter:

- **Colors & backgrounds**
- **Type fonts**
- **Frames & tables**
- **Navigation aids**
- **Hyperlinks**
- **Way cool additions**
- **JavaScript applets**
- **Animations**

Websites are made up of many functional and graphical elements. You won't need all of the pieces described in this chapter, but you should know the possible choices so you can pick and choose wisely.

HTML & Other Web Languages

The most basic web language is HTML (HyperText Markup Language). Basically, it is a structured language in which words and symbols are used to describe how the page should *look*. It is not difficult to understand in concept, but it is meticulous—and one mistyped symbol can cause failures or results you don't want.

Most Internet browsers allow you to view the source code of a site to see this language. The box on the next page shows an example. (Check under the command VIEW and click on SOURCE in Internet Explorer.)

The newer programming languages, such as JavaScript Applets "mini-programs," can be added to the HTML source code language. The Flash

Viewing Source Code

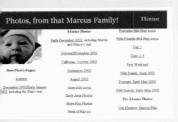

Right: You can view the source code on most sites to see the language that is used to build them.

```
<html>

<head>

<title>PhotoCentral</title>

<meta http-equiv="Content-Type"
content="text/html; charset=iso-8859-1">

<style type="text/css">

<!—

.Titlestyle { font-family: Georgia, "Times New
Roman", Times, serif; font-size: 32px; color: #FFFFCC;
background-color: #660099; background-position:
center center; border-color: #6666FF #6666FF
#6666CC #6666CC; border-style: groove; border-top-
width: medium; border-right-width: medium; border-
bottom-width: medium; border-left-width: medium}

.notesstyle { font-family: Georgia, "Times New
```

```
Roman", Times, serif; font-size: 16px; color:
#FFFFCC; background-color: #660099; border:
medium #6666CC groove; height: 128px; width:
684px}

—>

</style>

</head>

<body bgcolor="#FFFFCC" text="#660099"
link="#660099" vlink="#660099"
alink="#660099">

<table width="743" border="0" cellpadding="0"
cellspacing="0" bgcolor="#FFFFCC">

  <tr align="right">

    <td valign="middle" height="79"
colspan="4" class="Titlestyle">
```

program can be used to add new animation capabilities and interactivity. Dynamic HTML (dHTML) combines HTML with JavaScript, Cascading Style Sheets, and other scripting concepts to create a more controllable and interactive version of the older language.

WYSIWYG Software

The good news is that for a simple family site (or even a multi-page site with complex links and pages), you don't need to know *any* source code.

Most simple WYSIWYG ("what you see is what you get") software will allow you to push the text and visual elements around the page, resize them at whim, and change the colors of fonts and backgrounds with one click. The software then later converts what you have created into source-code language that Internet servers can understand.

Near Right: Web Easy is a good example of WYSIWYG-type software. You load it onto your computer, design your site, and then upload it to your host to "go live."

Far Right: Some hosts, such as Homestead shown here, have their own software that you access online to build your site.

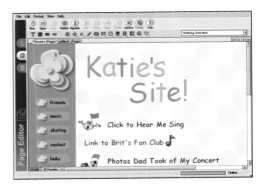

Excellent examples of WYSIWYG-type software are supplied online by Internet hosts. More powerful programs can be purchased and loaded onto your computer. See the Resource Appendix on page 134 for more options.

Makeup of Websites

The easiest way to understand the makeup of your website is to envision it in the material world, as opposed to the cyber-world! Think of your website as being made up of layers of clear plastic: On the bottom layer, you will paste a backdrop; on another layer will be a photograph; on another the navigation bars; on another the type, and so on. When you take all these layers and stack them together, they form a full picture. Obviously, if the back-ground layer were on the top of this stack, it would block everything else—so the order they are stacked makes a difference.

Some software will let you visually over-lap elements when designing the site, such as type over photos. Even so, make sure you use the "preview" option to make sure this doesn't cause problems when you go live. Overlapping or close objects can often cause one of the ele-ment to disappears or be cut off when you view it after the site is launched.

Color Palette

One of the first choices you'll have to make in designing your website is the overall color scheme. Your choices of colors come from your color palette. If you're old enough to remember the first home computers, you were usually look-ing at a black screen with greenish type.

Left and Below: HTML language specifies colors in terms of a six-digit hexidecimal color. You can use "swatch" charts to pick colors, or a color wheel (as shown in Quark Xpress).

Next came "amazing" (for the era) moni-tors and computer systems that supported 256 colors. The 1980s were the heyday of the GIF, a graphic format that used these 256 colors. Photos looked choppy, but they still *seemed* impressive at the time.

The next big leap was to more powerful computers and 16-bit monitors that could display 65,000 colors. Photographs began to look much more like photographs! Today, you'd be hard pressed to find a new monitor for sale that has less than 16.7

million colors (24-bit color) and display seamless, true photo-quality images.

The "web-safe" palette, also called dither-free colors, is actually a grouping of 216 colors that can safely be depicted on both PC and Mac computers. Even so, this limited palette is pretty much outdated, especially if you don't need precise colors (as opposed to a clothing store, for example, that must match precise fabric swatches). If exact color is important to you, check sites like webmonkey.com for the latest information on reliable color matching. Monitor technology and browser capabilities are changing so fast that new rules are constantly being made.

Color Systems

RGB: Monitors display the world in RGB (red, green, and blue) colors. The 16.7 million colors on a 24-bit monitor are displayed by combining different amounts of red, green, and blue light.

CMYK: In order to print a picture on a four- (or more) color printing press, it must be converted to CMYK colors. This is because books, magazines, and homemade inkjet prints are printed in ink

Master Checklist for Planning

THE MOST BASIC
- ❏ Color Palette
- ❏ Size on Monitor
- ❏ Background
- ❏ Text as Design Element
- ❏ Font or Type Face
- ❏ Headline GIFs
- ❏ Photos & Other Visuals

ADDING PIZZAZZ
- ❏ Fancy Buttons
- ❏ Revolving Photographs
- ❏ Rollover Photographs
- ❏ Animations
- ❏ Music & Sound
- ❏ Video Clips/Movies
- ❏ Guest Books & Databases

ADDING FUNCTIONALITY
- ❏ Frames
- ❏ Tables
- ❏ Navigation Aids
- ❏ Hyperlinks
- ❏ Thumbnails
- ❏ Metatags

WAY COOL ADDITIONS
- ❏ JavaScript Applets
- ❏ Virtual Albums & Galleries
- ❏ PDFs & Downloadable Files
- ❏ Search Engines
- ❏ Cascading Style Sheets
- ❏ Flash & Animation

(not the lights of a monitor) and must be built out of cyan, magenta, yellow, and black inks. Your home computer converts the RGB monitor image to CMYK before making the prints.

HEXADECIMAL: Website language defines colors in a hexadecimal, six-digit code to designate colors. You can use a chart to look up these exact colors and define them in your website. It's easier to use WYSIWYG software; you can pick from a vast palette of color swatches.

You may hear references to CLUT, the Color Lookup Tables. If you have a "swatch" book or chart that lists colors by percentages or hexidecimal codes, you can copy that information.

Background

One of the first design decisions you will make will be your background design. It will set the tone for your site. You'll probably want to keep a consistent background color scheme through all your pages to create cohesiveness on your site.

PLAIN WHITE: The simplest background is plain white. Like a sheet of paper, letters on white are easy to read, and most photographs look good against white. Many commercial websites go with white because it is clean-looking and their products stand out well against the background. They communicate their logo colors in the graphics and frames instead.

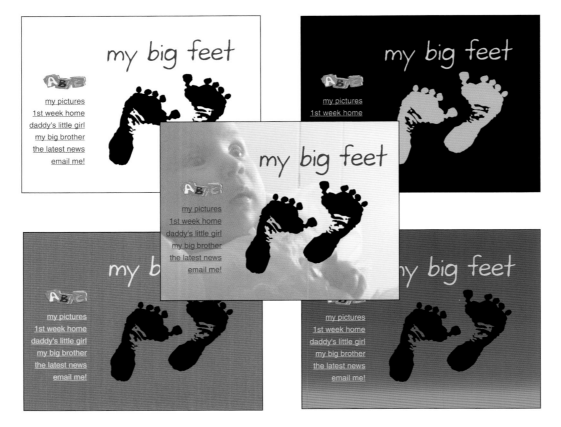

Left: Your first major choice is the background color, because it has a major impact in the overall "feel" of your site.

BLACK: Black can look sophisticated and tends to make photographs look very rich. Photographers' sites often use black for this reason. It also gives the feeling of watching a slide show in a darkened room. However, it can be difficult to view a black background for long periods of time, and small type can be hard to read. Also, if the viewer's printing preferences are set to print the background, they will waste a lot of ink and time printing that black background. (In newer versions of Microsoft Internet Explorer, to stop the background from printing you must go to TOOLS/ INTERNET OPTIONS/ADVANCED and unclick the box that reads, "Print background colors and images.")

COLORS: Background color is an excellent way to unify a site if you stick with it across all the pages. Jumping from one color scheme to another may make the viewer think she's left your site. If you're using a lot of photographs, select your color carefully. A red background can make one photo sing and another look dull. Instead, it may be easier to use color in a frame (see page 72) rather than the background to unify the site.

GRADIENTS: The colors don't have to be solid. A nice effect is the gradient or blend. Usually, you start from a solid color and gradually fade to weaker percentages of it until it turns white or another color. By rotating it, you can fade from top to bottom, left to right, or vice versa.

PATTERNS: Patterns might look great at first but they quickly become distracting, especially if you have type that is overlaid on top of it. If you really want

Your Background Color Sets the Tone

Don't pick a background color just because it's your favorite color. Few photos look good against a purple background! The tone you pick will have a major impact on the overall feeling of the site.

Every year there are new color schemes that are very hip, and you will see many websites that reflect them. You're welcome to use these tones, but remember you'll probably want to update them when they're no longer trendy.

You may want to decide between a cool scheme or a warm scheme. Reds, browns, yellow and oranges fall in the warm shades; blues and most greens are in the cool shades. Primary colors (bright red, green and blue) are often associated with children's sites.

a pattern, try to make it as subtle as possible, like a light blue family crest over a *slightly* darker blue background. If you go to contrasting colors or bold patterns, it will be hard for the viewer to read text or look at photographs without getting vertigo.

PHOTOGRAPHIC BACKGROUND: Unless you have just the right photograph, it will be hard to pull this off. The website shown on page 95 works, but that is primarily because it was a lopsided photo

with a lot of blank background space on the right and bottom (i.e., the water). So, in essence, it was more like having a small photo of the boy placed over a blue background.

Even so, the photo was not repeated on the remaining pages of the site. It simply would have been "too much of a good thing." Instead, the secondary pages "echoed" the homepage by using a background that matched the color of the water.

Text Is a Design Element

Don't overlook the visual power of the letters themselves. Certainly, the words have meaning in terms of what they say, but they also have a design function.

Text boxes

WYSIWYG software allows you to draw text boxes in your website design. You can type into it, as you would a Microsoft Word document, and then change the font type, the size, or the color of the text.

Often, the icon for a text box is a square with the letter "A" or "T" inside. This text box becomes a graphic element that can be moved around or resized just like a picture box.

The text box can have a background color of its own, such as red, so that it is opaque. Or, you can select TRANSPARENT or NONE (NO COLOR). This is like printing the text on overhead transparency film— the type is opaque, but you see through the text box to the background or photo.

Rolling Paragraphs

In most software, text boxes have an exactly set size. Rolling paragraphs, on the other hand, allow the type to readjust itself depending upon how large the user has opened the browser window open in the monitor. This eliminates scrolling to the right to finish reading a line if the site appears wider than the screen.

Font or Typeface

The monks of the Middle Ages who created masterful illustrated manuscripts understood the concept of fonts. A word or a letter could become an artistic entity of its own, as well as an integral part of a page design.

Today there are thousands of English-language fonts and specialized fonts that offer a different, artistic interpretation of letters or symbols. For example, the designer of this book chose the font AGARAMOND for the main text because it is easy to read and fits a lot of letters into a small space.

The **text headlines** are bolder and larger, and help break up the page graphically, but also clue the reader into what to expect in the next few paragraphs. They are FUTURA CONDENSED BOLD, and are set to 75% density (SHADE) to appear as gray.

The frilly "**Ingredients in a Website**" chapter head is light and spirited, but it would be hard to read if it were to flow for more than a few words. This font is KHAKI TWO.

Most computer operating systems come with a selection of different fonts. Others

can be bought or acquired for free and added to the system. Do an Internet search under the keywords "font" and "free" and you'll be surprised at how many you might find. Inexpensive CDs of fonts are also available.

Aside from a few common fonts (the plain vanilla typefaces), you can't count on the viewer having them loaded on their computer. If they don't, their Internet browser will automatically change them to a default. This could cause your site to look

There Are Many Ways to Vary the Type Face

THE FONT ITSELF: There are tens of thousands of different fonts, each of which makes letters and symbols look a little different.

SIZE: Fonts are usually measured in point sizes. Larger points mean a larger size relative to other fonts.

COLOR: You can pick any color for the letters. Make sure they're readable against the background!

SHADE: Some software lets you soften the color by lightening it by a certain percentage.

BOX BACKGROUND: The box that holds the type can be colored or transparent (COLOR NONE). A colored, black, or white box will sit as a block of color on top of the background. Transparent text boxes will also sit on top of the background but will be transparent except for the letters.

BOX FRAME: You can use a frame to outline the box with a black, white, or colored line of selectable width.

JUSTIFICATION: This refers to how the type lines up on the left and right sides. See sidebar on page 69.

Right: You have a great deal of control over the look of the words on your site. You can change the font, as well as its size and color. You can also alter the box that holds these letters, making it invisible, white, colored, or framed.

radically different to each viewer. The main ways around this are as follows:

1. Use only standard, common fonts. A list of common PC and Mac fonts are listed in the sidebar below.

2. Turn specialized fonts into GIF graphics and insert them into your website as you would photographs. (See page 68.)

A Few Safe Fonts

Not all computers have the same fonts installed, so they may make substitutions if you use a non-standard font. This could cause your site to look different unless you take certain measures (mentioned above).

A few safe fonts that come installed on most computers' operating systems are listed below.

FONTS FOR PC (13pt SIZE):
Arial
Helvetica
Times New Roman
Veranda
`Courier News`

FOR MAC (13pt SIZE):
Geneva
Times
Helvetica
`Monaco`

3. Learn some advanced techniques like EMBEDDED FONTS, which actually "embed" the font in your website language so the font file downloads with your website file to the viewer's machine.

A Few Words on *Words*

How big a size do you want the type to be? Your choice should be determined by five factors:

1. HOW MANY? Writing for the Internet is a fine art that differs greatly from most other types of writing. You should try to keep your text short, concise, and to the point. Nobody really wants to sit at a computer monitor and read—but they probably do want the information. It is therefore your job to keep your writing succinct. Consider adding extra web pages or PDF downloads of longer text (see page 83).

2. WHAT LOOKS GOOD? Don't forget that your words have a design function in addition to their editorial role. Short sentences in short paragraphs look much more inviting than massive blocks of text. Try to break it up with subheads (like the phrase, "A Few Words on Words," shown above.

3. HEADLINES? Headlines are a great way of graphically enhancing the design of your site. The header text should be to the point and a synopsis of the text that follows. Avoid cute or clever headlines that don't communicate this information. Many people like to scan headlines to determine what sections of the site to read, and succinct headlines will help.

96pt., 48pt., 24pt., 12 pt,, 6pt.

4. TOO SMALL TO READ? Different monitor sizes and different display settings on those monitors can result in the type appearing, to some viewers, to be different sizes.

If your monitor is adjustable, set the display to the smallest setting (usually achieved through the control panel). Can you still read it when the window is this small? If not, consider making it larger.

Type smaller than 12 point can also have aliasing problems (see page 69).

Below: You can "cheat" and create a fancy GIF text with drop shadows by using a graphics or photo-editing program to overlap two text boxes and then saving the result as a GIF graphic.

Creating Drop Shadows
Creating Drop Shadows
Creating Drop Shadows

5. AGE OF YOUR READERS? The better eyesight of youth means they may not have trouble reading small text. But an older audience may need bigger type.

Font Colors

Just like background colors, the color of your font affects the site design and the readability. Yellow type, for example, can be hard to read on any color background. In general, dark fonts are easily read against light backgrounds and vice versa.

Creating Drop Shadows

Want your text to jump off the page? Or need it to have yellow in it to match a photo, even though yellow is hard to read? Try this trick in photo-editing or graphics software: Make two copies of the text box with a transparent (NONE or NO COLOR) background. Change one to a different color and stack them slightly askew. Use the BRING FORWARD or MOVE BACK (or similarly named) command to put one color on top of the other. Then, group the two so you can move them around in tandem. Save this as a GIF, and you can insert it into your website as a photo.

Drop Caps

Both modern magazines and medieval manuscripts make frequent use of drop caps. Basically, drop caps mean that the first letter (or word) of a paragraph uses a bigger font size. This is simply to make the text more graphic by making a big, bold design out of the letter.

This paragraph has a three-line drop cap for the first four letters. The example in the above paragraph is a two-line drop cap of the first letter. Some software makes it easy; other software doesn't offer it.

If you really want a drop cap, and the software doesn't allow it, you can always create a GIF graphic of the letter and insert it as a photo in front of the paragraph. For the best results, you'd then have to set the type to WRAP around it.

Leading

Leading affects how much white space is between the lines of text. It is pronounced like the word for the metal because, in the old days, snips of lead were placed between the lines of type on a printing press.

In general, larger type sizes have bigger spacing between the lines. If the leading is too tight, the bottom of one row of letters might overlap the top of the next row.

Some software programs only allow the old typewriter choices of SINGLE SPACE and DOUBLE SPACE. They set a default leading size based on how big the letters appear.

Advanced software programs allow you to make very minute changes in distance between the lines of type. This has an big affect on how dense the text looks on the page.

Kerning

Kerning is the space between the letters themselves. Kerning larger than zero gives a feeling of openness. Taken to extremes, the letters can look like separate words.

Turning Words into GIF "Photos"

Want to use fancy types to create headlines or family "logos?" Load the font into your computer, write something in a photo-editing or graphics program, and then save it as a GIF.

Be sure to select a transparent or COLOR NONE background for the text, so it can be laid over the background or over a photo on your website.

Later versions of Microsoft Word have a function called WordArt that lets you alter the type into over two dozen designs, including curved and skewed type and other special effects.

Here is example of normal kerning (0) for this book. The leading is set to 14pt.

Here is an example of really tight kerning, set at -20. Notice how many more letters I can fit on one line, but it is hard to read.

And here we go with superwide kerning set at +20. It is much gappier.

Aliasing vs. Anti-Aliasing

Computer monitors display images by breaking them into dots that are displayed on the screen. The more dots, the higher the resolution and the smoother tones and lines appear. But sometimes you can see "jaggies" or aliasing. These are the rough edges created when there aren't enough dots to smooth out curves and diagonals.

Surprisingly, type is one of the hardest graphic elements to smoothly reproduce on a computer monitor. Jaggies happen in photographs too but, because of the many tones and the unpredictable shapes and textures in most photographs, they are much less noticeable.

Most good web design, graphics, and photo-editing software programs give you the option of selecting ALIASING or ANTIALIASING of the fonts. Anti-aliasing basically fools us into seeing a perfectly depicted letter with smooth edges. It works fairly well on large type. Unfortunately, once the type starts getting smaller than about 12 points, it begins to blur noticeably. In these cases, it is wise to turn off the anti-aliasing feature.

Type Justification

Just like in a Word document, you can change the justification of your type.

THIS PARAGRAPH IS JUSTIFIED. When the type is "justified", the type lines up in a neat row on the right and left sides. However, while this looks neat and orderly, the program often has to put uneven and sometimes large gaps between the words. This can make it hard to read.

THIS PARAGRAPH IS FLUSH LEFT. Left justification (also called FLUSH LEFT) is probably the most common choice for the Internet. The left side of the type lines up evenly and the right side ends "ragged," a little longer or shorter depending on the length of the words.

THIS PARAGRAPH IS FLUSH RIGHT. Right justification (also called FLUSH RIGHT) is sometimes used when you have a photo to the right of the type and it looks prettier to have the straight edge of the type line up with the photo's edge. This leaves the ragged side on the left.

THIS PARAGRAPH IS CENTERED. Centered is just what it sounds like— an equal space remains on the right and left sides. This is nice for head- lines if you want a newspaper look, or for short blocks of text.

Photos & Other Visuals

You'll find an entire section of this book devoted to collecting and preparing photographs, artwork, memorabilia, and other graphics for the Web, beginning on page 22. Suffice it to say here, GIF, JPG, BMP, and PNG picture formats are treated like "photos" in web software—whether they are headline type, a logo graphic, or an actual digital photograph.

Using the WYSIWYG-type software discussed in this book, you place photos within your design by creating a photo box and then selecting an image or graphic to fill it. The software doesn't care if this is really a photograph or if it is a scan of a wedding invite or any other visual.

3

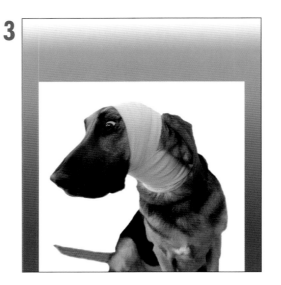

The original image (1) is busy and confusing. In the next photo (2), the background was retouched to white. However, a white background (3) leaves a white box around the picture on the site, while a silhouette or transparent photo (4) lets the site's background shine through.

1

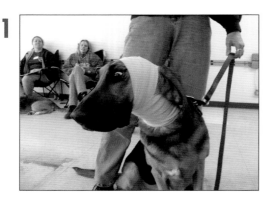

2

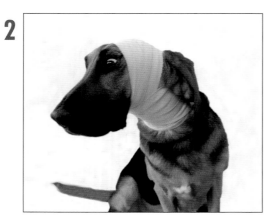

4

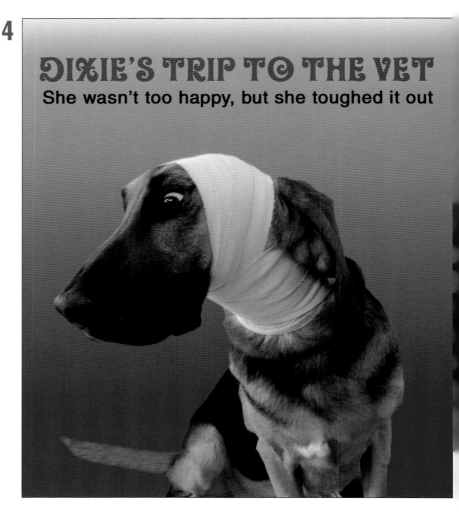

DIXIE'S TRIP TO THE VET

She wasn't too happy, but she toughed it out

This photo box can then be made larger or smaller while the image remains proportional, or squashed/stretched so that the image is also distorted.

Some web design software will let you crop the image on the fly. Most require that you plan ahead and crop the photo to size before importing it into the web software.

In either case, it is always better to crop the photo to the right ratio and resize it to the desired size *before* you add it. This will help to conserve the overall file size of your site and shortens the length of time visitors must wait to access your site.

If you want the photo or graphic to be silhouetted, you need to prepare it in photo editing or graphic software. A silhouette (or "transparent" GIF) usually features the main subject with all or some of the background removed so that it takes on the shape of the subject. The result? The background shines through the photo box everywhere that the subject is not.

Advanced programs enable you to make some photos and graphics partially transparent. The result is they become semi-transparent, enabling what is underneath to be partially visible.

If this cannot be achieved in your web design software, you can fake it by combining the graphics in photo-editing software, such as Adobe Photoshop or Adobe Photoshop Elements (using the LAYERS function), and saving them as one image. The copyright insignia on the photo on page 32 is an example of partially transparent type (opacity 35%).

Creating Easy Silhouettes

Don't want a square photo? Just want the contours of the main subject? You can turn your photo into a silhouette or "cutout" in most photo-editing software.

Remember, with a silhouette the goal is not a *white* background for the picture. You want a transparent or see-through background (often specified as COLOR NONE).

To do this, you must outline the subject and then CLEAR or CUT the background. Most programs provide more than one type of CLIPPING tool to do this, including AUTOMATIC and MANUAL.

AUTOMATIC: The program automatically determines the outline for you. This really only works well if your subject has a clean outline and is set against a simple background, so the program can easily pick up the shape.

STICKY or MAGNETIC: You tell the program roughly where to cut and it determines the finer outline.

MANUAL: You click on "cutting" points along the outline. This is extremely accurate, but very time-consuming, especially when cutting around hair or complex outlines.

Adding Functionality

Frames

Frames are an extremely popular web design option. In layman's terms, they subdivide your page into separate pages that appear as one to the viewer. A common frame design would have a separate top bar frame (usually with a logo and tab navigation aids) and a left-side frame (also with navigation aids).

Frames are most important to designers of large sites because they separate the relatively static top and left from the main content (everything else). For example, an e-commerce site with 500 pages could use the same top frame on every page.

Not only would this save file space (because the code wouldn't have to be rewritten for every one of those 500 pages), but the designer could a make a slight change to the master page (such as to announce a sale), and it would be changed on all 500 pages.

This isn't going to be a factor for most family websites, but it can still be a nice design method. By "locking into" frame structure, you force yourself to create a more consistent-looking website.

Frames are also an advantage on long pages. As the visitor scrolls down the main page, the side or top frames with the navigation bars will remain unchanged (they won't scroll), keeping their navigation aids and other information still visible.

Left: A frame is created across the upper portion of the website (here shown in Internet Design Shop software). This frame is treated as a separate "page," though it is designed to go across all pages.

Left: The bottom frame is now broken vertically into a frame, yielding three separate sections.

Left: A background image of clouds was chosen for the top frame. This image will greatly affect the overall tone of the site.

Left: The top frame is set to the headline, "The Bidners." As the visitor moves from page to page on the site, this top frame will remain unchanged.

Right: The left frame is turned into the main navigation system for the site.

Far Right: A screened-down version of the clouds becomes the background for the main page.

Frames used to be a difficult and complex programming issue. They are still in the realm of the advanced, but higher-end software has made designing frames much easier. Some programs let you instantly select one of several frame structures and then begin to customize it to your liking.

Tables

Tables are related to frames, because they have a similar structure of separate sections. Tables in the web world are not that different from tables in a word-processing program like Microsoft Word.

Right: Pictures, pictures, pictures! The Marcus family couldn't wait to publicize the birth of their baby, and supplied thumbnails in a left-hand frame that yielded enlargements to the right when they were clicked on.

You determine the number of rows and columns you want, and thereby the number of cells (compartments) they create. You can combine (MERGE) two rows or two columns to make larger compartments. You can also PAD these cells, which means determining the amount of blank space or cushioning around the text. And, in fact, a left-hand "frame" can be produced by combining all the cells in the first column of a table. Or, a table with one column and two rows provides a two-cell setup for a sidebar, with the top cell for the headline and the bottom for the copy.

In some cases, you can select whether the table cells will hold words (text), photos, graphics or a combination. A table grid can make a nice template for a thumbnail photo gallery so that all the photos line up neatly.

Avoid the temptation to make data charts without using the table function. If you use the typewriter method of trying to line up data with spaces and tabs, the table may or may not line up when the visitor views it on their monitor.

Tables vs. Text Boxes

If you're working in WYSIWYG software that offers text boxes, you don't really need to use the table system—unless you actually need a chart. Think of text boxes as individual table cells you can place anywhere on your page.

Hyperlinks & Navigation Aids

Hyperlinks are any click-link that takes you somewhere else in the website, to another website, or to a specialized function, such as an email window or a downloadable file.

Most people associate a hyperlink with underlined text that is a different color, such as blue. However, you can attach a hyperlink to text (HOME), to a picture or graphic (sometimes called an IMAGEMAP), or to a navigation aid or button.

Above: Tables allow you to easily list information like calendars and price sheets. However, they are also a nice way to line up thumbnail photo galleries, or a mix of text and pictures. Double wide cells can be created by MERGING two individual cells.

Left: Linking pages or sites is an easy task in most online or standalone WYSIWYG software. Simply click on the element and identify where you want it to link.

NEXT

Above: Navigation aids can take on any form, from "Click Here" text to graphic buttons and photographs.

Most WYSIWYG software makes linking very easy. Usually you can use pull-down menus to create a link from a photo, a navigation aid graphic, or a word.

In addition to linking to the next page in your site, you can choose to link to any number of things:

1. An instant jump back to your homepage, or a jump forward to another page.

2. A specific spot on another page (sometimes called a bookmark). This is useful if you have a long page with a lot of text because it eliminates the need for the viewer to scroll down.

3. You can link to another website entirely. This is often done through a links page, where you offer recommended links of interest to your visitor. You can also link to a mapping company (such as mapblast.com or mapquest.com) if you need to help somebody with directions to your house.

4. You can earn commissions by recommending products through "affiliates" programs. (See page 131 for more information.)

5. Open an email window, pre-addressed to your email account, so visitors can conveniently write you a note.

6. Link a small photo (thumbnail) to an enlarged version of a picture with or without an accompanying caption.

7. Link from a still image or description of a video clip to the actual clip. This allows users to decide, based on the description, whether they want to spend the time to view the video.

8. Near the video link, you can include a link for downloading a free "player" in case the viewer doesn't have a compatible one loaded on their computer. Companies like Macromedia will provide you with banners and special links to add to your site, to make accessing the free software easier.

9. Audio files can be played automatically as background music, or downloaded through a click-link. Free audio players are available from companies like Real Media.

10. Create a link called "PRINTABLE VERSION" to connect to a page that is a simplified version of the page on view, making printing neater and easier.

11. If you have a long or complicated document (such as a registration form for a soccer team), you can provide it as a downloadable file. Adobe Acrobat creates easy and compact PDF (Portable Document Format) files. (The reader is free, but you must buy the software to create a PDF.)

Home Links

Include a HOME link on every page of your site (except the homepage itself). This is so that, eight pages into your site, the viewer doesn't don't have to do seven hits on the BACK or PREVIOUS buttons to return there.

Whether you use bars, buttons, or words, you'll need to provide navigation aids for any website that is larger than one page. This can be as simple as the words HOME, NEXT, and PREVIOUS, that have been hyperlinked to the appropriate pages.

The most common placements of navigation aids are the bottom of the page, the left hand frame, and the top bar. Some designers use all three.

The top and side are popular because they are visible when the page loads. By the same token, if the visitor has already scrolled to the bottom of the page, the top and side navigation aids might be invisible (unless you are using frame structure—see page 72). I like to have fancy bars on the left or top, and at minimum, simple text links on the bottom so they are visible when you've scrolled to the end.

Though these are the three most common spots that people look for

Reverse Chronology

When updating your site, place the newest photos or videos at the top of the page so that, as your website gets older, it shows up in reverse chronological order. It takes a bit more work on your end, but your audience will appreciate it. When they check in to see what's new, they'll immediately be rewarded, rather than having to scroll though countless pages.

navigation aids, they can really be placed anywhere that works from a design sense. You can even design a complex graphic that has the links embedded within it (an imagemap), so that, depending where you click on the graphic, you are sent to different links.

Secret "Easter egg" links can even be hidden in the site, like those found in popular computer games. This allows visitors who are "in the know" to find special links to otherwise-hidden parts of the site that the general public would probably miss (unless they accidentally clicked on the link).

There are countless varieties of traditional navigation graphics available for free or for a small fee. If you can't find just the right wording in readymade clip art, you can create your own in illustration or photo-editing software or even in Microsoft Word (see page 33). Even the simplest graphics program will allow you to create a colored box or oval and overlay white or black type on top of it. Save it as a GIF and you're ready to go.

Common navigation wording includes: HOME, NEXT or FORWARD (or a right arrow), PREVIOUS or BACK (or a left arrow), EMAIL, LINKS, NEWS, CALENDAR, MESSAGE BOARD, GUEST BOOK, UPCOMING EVENTS, PHOTO GALLERY, VIDEOS, ARTWORK, GENEALOGY, SITEMAP, PRODUCTS, or the names of individual members of your family.

Literally, any picture or graphic can be used, but it must make sense to the visitor or they'll never click on it. If you use

a photo or cartoon for the link, it is wise to also have text link below the picture in case the graphic doesn't load or the meaning is too obscure.

Have some fun! Does each member of your family have his or her own email or a separate page? The navigation aids to get to their sections can be their pictures or meaningful clip art graphics. If it is not abundantly clear that it is a click-link, be sure to put a textual link below it.

Thumbnails

Big pictures and video files take time to download, especially if your viewers are still using a telephone modem. Help them out by showing a preview of the photo or video in the form of a postage-stamp-sized image called a thumbnail.

The exact size of the thumbnail is up to you. It can be the entire picture shown small or just a detail, such as a closeup of a face or smile. The idea is to let the viewer decide if it is worth time to click and download the larger version. Or, she can scan the thumbnails to see if any new photos have been added since her last visit.

A thumbnail is actually saved as a separate photo, resized to a one- or two-inch (2.5 to 5 cm) size. I like to rename the smaller version with a prefix or suffix, such as TN, so I never confuse the two. (See page 90 for information on resizing.)

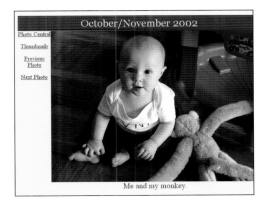

Me and my monkey.

Right: A good way to handle a large number of pictures is the thumbnail page. The visitor clicks on a "mini-picture" to link to a larger version (with or without a caption).

Avoid Confusion

Some people might be confused and think that the thumbnail is the biggest version available. Therefore, you should include instructions that say something to the effect of, "Click on the picture to see it larger."

After the thumbnail version is added to the design, it is designated to link to a page that consists of the larger photograph (or the larger photo with a caption).

The enlarged photo can appear in a new window (like a pop-up window) or as the next page in a linear site. With the pop-up version, the viewer would have to eventually close the extra window after viewing. In the latter version, she'd need to click BACK to return to the thumbnail page.

A page in your site might have just one thumbnail, or you can create thumbnail galleries. This is a popular way to handle photo galleries.

Some software programs have templates for thumbnail galleries. You can also make your own from scratch. A table is a handy format if you use the cells (the boxes created by columns and rows) for photos instead of text. This has the advantage of helping the thumbnails line up on a clean-edged grid.

Avoid the temptation to make a really long page full of thumbnails, because the viewer must scroll down and down and down to see them all. You may be better off making several pages with 9, 12, or 20 images, which also lets you to group them by event, subject, or date.

You can also choose to place headlines and some caption text underneath each thumbnail if it needs more explanation. In case the thumbnail doesn't load (or takes a long time to show), this description will help the viewer decide if they want to take the time to see the enlarged version of the photo.

Metatags

Metatags are an important part of Internet functionality. Basically, metatags are invisible texts that contain brief descriptions of the content of the site or a specific page. Pick these words carefully, because these metatags are then checked by "spider" search engines—so named because they crawl around Internet sites and gather or catch information.

The TITLE, KEYWORD, and DESCRIPTION information in metatags is then used to categorize your site and your individual pages for search engines, such as AOL Search, Yahoo, AltaVista, Google, and more. If you leave your metatags blank, the search engine might pull words off the homepage, which is far less effective than carefully crafted metatags.

There are rules for "fair play" in creating these metatags, and you can get tossed off search engines if you break them. See the Resources Appendix on page 138 for sources of information on search engine optimization.

Avoiding Search Engines

If you prefer not to be included in search engines and are willing to add code to your site manually, you can slow them down by using a special code such as:

```
<METANAME="robots"
content="noindex,nofollow">
```

Way Cool Additions

It's tempting to get charmed by technology and want to add every new gimmick to your site—blinking animations, background music, movie clips, rollover photos, interactive games, mouse animations, and cool JavaScript mini-programs. However, resist the temptation to add something *just* because you can.

What Will It Add?

Before adding an element to your site, ask yourself two questions: Is it worth the extra file space for me? And more importantly, is it worth the download time for the visitor? If the answer is no or even maybe, then you should probably skip it.

JavaScript Applets

JavaScript is an Internet language used to make little programs that are dropped into your HTML documents. They are called Script Codes or Applets. They are usually compact in terms of file size and don't require that the viewer download a special viewer (as you do with Flash).

Great JavaScript Applications

❏ **TODAY'S DATE:** Make your site seem up-to-the-minute by automatically changing the date.

❏ **VISITOR COUNTERS:** Track the traffic to your site!

❏ **AVOID SEARCHING:** Hide your site from search engines.

❏ **FORMS & DATABASES:** Collect information from your site viewers. You can have them write in responses or simply click on check boxes or buttons to respond.

❏ **GUEST BOOK:** Basically, this is the simplest type of database. The guest fills in her name and comments. You can decide if these posts should be public (VIEW THE GUEST BOOK) or private.

❏ **TICKER-TAPE MESSAGES:** Include live information from an outside vendor, such as stock quotes, weather reports, or public services such the missing-child Amber Alert.

❏ **RIGHT-CLICK DISABLE:** Make it harder for viewers to copy your pictures by using the SAVE PICTURE AS option.

❏ **PASSWORD PROTECT:** You can add simple password protection to your site.

The cool thing is that you don't really need to know anything about writing JavaScript script to use it. You just copy the code and place it in your software. Most of the WYSIWYG software programs include a few choices, and most allow you to add your own.

These applets can be bought, copied from books, or cut-and-pasted from free sites. See the sidebar on the previous page for some of the types of programs you can easily get. Do an Internet search using the keywords "free java" and the type or script you want, such as "database."

See the sidebar on the previous page for some of the types of programs you can easily get.

Advanced Databases

If you're truly interested in collecting data, you'll need to invest some time researching the different programs and formats. Your Internet host may provide some simple scripts for collecting data. If you use the very popular business database software program Microsoft Access (MDB files), you'll want to be certain your data collection is compatible.

Fancy Buttons

Simple animation or rollover graphics can create buttons that look and "feel" real. If it looks three-dimensional and it "pushes in" when you click on it, you can create a pleasant virtual experience of clicking a button to access information, games, etc. Ready-made versions (just add them to your site) are available for purchase and sometimes for free. They are really just simple forms of animation.

Animations

Simple GIF animations are also available as clip art. These include things like a prancing dog that bounds across the website or a baby that winks at you. More advanced animations utilize Flash graphics and other new web-compatible programs.

Fancy text that blinks is certainly an attention-getter, but it has been so overused by zealous e-commerce companies that the blinking "Sale!" sign has become a cliche.

Left: Guest books allow your visitors to add comments to your site. You can allow other visitors to view this guest book.

Left: Buttons can have a realistic look, like three-dimensional keyboard buttons, or they can be more abstract, graphic forms. At left are several options supplied by Homestead's online software.

However, if used judiciously, you can have some fun with it. It's basically a simple form of animation.

Photo Effects

Your photos can be set to revolve (change) at timed intervals or when the mouse is rolled over the photo (rollovers). In a sense, this is animation, except that the photos don't need to be "sequential." They can be totally unrelated.

Basically, you load the photographs and then set the parameters for the switch. It's a simple selection feature in many WYSIWYG software programs. If the program does not offer this, you can add a simple JavaScript applet to activate it.

Sophisticated Animation

Flash, "faux Flash," and other sophisticated animation methods are beyond the scope of this book, but their advanced technology and capabilities

Right: Rollover photos change when you "roll" the mouse over the picture. Here, visitors can compare the original photograph with the final pet portrait created by the artist.

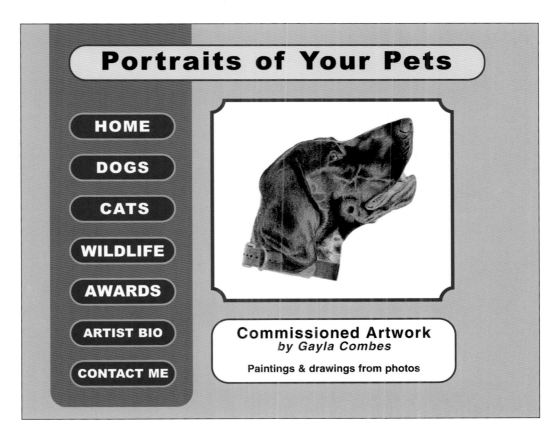

Ingredients in a Website

are amazing. Interactive and exciting graphics are just the tip of the iceberg.

Software programs, such as Shockwave Director, allow you to create complex mixtures of animation, videos, and music/audio and save them as SWF (Macromedia Flash file format) and DCR (Shockwave Macromedia Director) files. A reader, such as Macromedia Flash Player, is needed to "see" them. Though the software to create Flash segments must be purchased, the reader is supplied free through a link to the manufacturer's site that you can add.

At the time of publication, most new or relatively new Internet browsers can support Flash graphics and movies.

Music & Sound

Adding music and audio clips can be a great addition to your site if used wisely and for a reason. Just because you can add sound doesn't mean your should. My personal pet peeve is logging onto a site and having a sudden onrush of background music. I don't appreciate it on elevators or while I'm shopping, and I certainly don't want it invading my home!

Just as monitor display settings are not universal, neither is sound. What might sound soft and beautiful to you might roar out of your visitor's computer at a deafening level or sound like it is being played on a toy keyboard. If the visitor doesn't have external speakers, changing the volume can be a lengthy process involving going to the CONTROL PANEL.

Since the music itself needs to be stored as a file, most sites opt for short clips that repeat in an endless loop, making the music even more annoying.

Therefore, my suggestion is to just say, "No!" to background music. However, music with a purpose is another story altogether. A link for downloading your fifth-graders' chorus recital would be great, or a 3-second clip of your child's

Skip the Background Music

You can't control the volume or quality of the music your audience will hear out of their own computers, because their settings may be different and they may not have good external speakers. This means that they may be blasted with an earful of extremely loud, tinny music—reason enough to instantly close your website!

Therefore, think twice before adding background music. Only use it when you have a specific reason and it adds value to the overall experience. A good alternative is to supply a click-link so that the visitor can choose to listen.

Examples of good use of sound include personal greetings from family members, a colorful story read by your second grader, or a school chorus recital.

giggle that plays when you roll the mouse over the picture.

Note that there are many different types of sound files. Most no-charge sound effects are MIDI format, which makes them very small, but they only play as notes (rather than tones) and tend to sound like they are coming from a child's toy.

Higher-quality sound files like Windows Wave, MP3, and RealAudio are far better choices for voices and musical instruments.

Background music can be embedded into your site, so it automatically plays when a certain page is opened or a link is clicked. Larger files can be downloaded by the visitor and saved on her hard drive for convenient and repeated listening.

Streaming audio requires a host company that has this capability, and it is therefore more often found on professional websites. Instead of having to download larger audio/music files and then open and play them, you can stream them directly from host companies' sites. The listener cannot save it to her hard drive and can only listen to it while linked to the site. This is both an advantage and a disadvantage.

Video Clips/Movies

Online videos or movies are very file-size-intensive. Like the thumbnail photos mentioned on page 77, the best strategy is to give your viewer the choice of downloading them. I'd suggest showing a thumbnail picture (one or two inches [2.5 to 5 cm] large) of a key frame from the video along with a click-link to "VIEW THE VIDEO."

Details on preparing videos can be found on pages 30 to 31. However, the most important rule is, keep them short! Several 15- to 30-second videos will yield a more favorable viewing experience, compared to one longer five-minute segment. This is doubly true if the five-minute version is unedited.

Frames per second (how smooth or jumpy) and viewing size also affect file size/download times. While 30 fps is common for VHS videos, most online videos are viewed at only 10 or 15 fps.

Downloadable Files

The hyperlinks in your website can also be set to downloadable files of all types in most WYSIWYG software. A common type of downloadable file is the PDF, which is created in Adobe Acrobat. Here again, the software to write the PDF files costs money, but the reader is free.

The beauty of a PDF is that it is a "snapshot" of a page, so that you know exactly how it will be received and printed. Word documents and others might not appear exactly as you intended because of the default settings on the viewer's computer.

Cascading Style Sheets

Cascading Style Sheets (CSS) are popular in advanced sites, and are accepted by most of today's Internet browsers.

In most WYSIWYG software you won't ever see the term Cascading Style Sheet (CSS). Some of the advantages are simply built into the software. However, advanced web design software will allow you to have complete control of CCS design.

A CCS is really a set of rules or instructions that describe the minutiae of different elements of the design. Those familiar with page design software for books and magazines (such as Quark Xpress) will find the concept very familiar because creating style sheets is one of first steps in the process.

If, for example, you were designing this book, you would set up a style sheet for all the different typestyles. The style of the paragraph text would be different from the subhead above it. The font, the size, and the shading would be different.

The beauty is that you could write the text in any program (such as Word) or receive it as an email from a writer. You would then import or copy it into the design program and apply the appropriate style sheets. This would instantly convert it to the correct style, without your having to separately change the font, size, kerning, leading, etc. Not only is this a time-saver, but it avoids mistakes.

Websites are not unlike books in that you have multiple pages, but they're just not necessarily in linear order. You can also create a style sheet that describes font specifications, layout, etc. for the current page. It is then placed at the front of the document rather than embedded in the individual scripting code of each page.

The CCS sets up rules that will override the default settings on the visitor's browsers, allowing your site to appear on her monitor as you wanted. For starters, you'll get minute control over how your fonts appear, and you can do many of the things described on pages 64 to 69.

Simply by linking this style sheet to other pages, you can automatically have the information passed down to any other pages you wish. And if you want to

The Internet Hierarchy

If you don't write "rules" that describe how your site should be set up, you're at the mercy of your viewers' computers. Their browsers will decide how it should be viewed at the browsers' default settings. The advanced user can customize these settings and override the browser's default settings.

If the web designer creates external and internal style sheets, they can override the default settings for a browser. Then, on individual pages, they can override these general rules as needed. It's complex, but there is an established hierarchy that determines what styles get the "final word."

override some of these rules, you can still do so on the individual pages.

By pulling the specs "out" of the individual lines of code on each page, you eliminate the need to repeat them over and over again throughout the site. This might not make much difference in your small family website, but it would be a tremendous help for a commercial site with hundreds or thousands of pages.

This achieves four things: It reduces file size; it reduces initial scripting time (you just write it once); it reduces chance of error (you just write it once); and it allows you to make changes across all the linked pages by altering only the first.

For more information on Cascading Style Sheets, check out the World Wide Web Consortium website (familiarly called W3C) at www.w3c.org.

Filekeeping & the 404 Syndrome

Everybody who has surfed the net has seen this error message at one time or another: "404 FILE NOT FOUND."

Often the culprit is the website designer who changed the page but did not retain the naming system, or removed an important file. Or, she pulled down the page but forgot to remove its link from another page.

Therefore, it is important to retain your file names and folder names. If you made changes to your site but have

since renamed items on the site, they will not match those of your host.

Remember, it takes search engines a while to "find you" and list your page for key word searches. Likewise, they may telegraph that page name long after it exists. If someone follows this link, she will get an error message.

To make sure this doesn't happen and visitors can still hit your site, give the new page the same name as the deleted old one.

Chapter 4
Getting Organized

In this chapter:

- **Envision the finished project**
- **Determine your audience**
- **Keys to good Internet writing**
- **Develop a navigation plan**
- **Importance of your homepage**
- **Format your photos for the Web**
- **Understanding resolution**
- **Resizing your photos**
- **JPEG file format**
- **GIF format**
- **Other file formats**
- **Backing up your files**

Envision the Project

Before you do any designing, you need to analyze your goals. You are reading this book, so obviously you have the desire to create a website. But what is its purpose?

Some common goals for your family website may include:

1. Communicating with family and friends to organize events and share news.

2. Creating a modern, accessible version of the classic family photo album.

3. Organizing events or fundraising for your clubs, sports, or scouting activities.

4. Helping your children create their own pages as an educational project.

5. Sharing your professional or hobby knowledge and expertise, and networking with people with like interests.

6. Promoting a home business, selling products online, or creating a professional online resume.

7. It's no longer a difficult project, due to new software and inexpensive hosts!

Most likely, you will be checking off more than one of the aforementioned reason and probably a few more.

Regardless of which or how many, you need to decide on your goals ahead of time so you can make sure your website addresses each of these topics effectively.

Who is your audience?

Are you creating this site just for your family and close friends? Or do you want to broadcast it to strangers in the hope of expanding your home business or finding members of your family tree? Are you trying to link up with people who share your interests? Or do you

Good Internet Writing

❏ **KEEP IT SHORT!** Worry less about pretty prose and more about communicating the information quickly. What is good to read in a book (that you curl up with on the couch) is not necessarily good on the Internet. Here, the goal is to deliver the information as quickly and succinctly as possible.

❏ **BREAK IT UP:** Break up large blocks of text with headlines (like a newspaper, or even this book).

❏ **HEADLINES:** It's usually best to keep your headlines informational rather than cute or poetic. The goal is to allow your viewers to scan headlines to determine if they want to "bother" reading the paragraphs below it. They also serve a graphical purpose, so consider turning the headline into a fancy GIF graphic (see page 68).

❏ **GRAPHICS:** Use photos, animations, and other graphics liberally, but be sure to size them appropriately to ensure quicker downloads.

❏ **BULLETS & CALLOUTS:** Similar to headlines, bullets and callouts can be used to break up the page graphically and highlight important information.

❏ **SPELL CHECK:** Proofread your text and do a spell check before you launch! If your web design software does not provide this utility, then write it in a word-processing program, such as Microsoft Word, perform SPELL CHECK, and then COPY and PASTE the text into the web design software.

❏ **UPDATED & CURRENT:** Keep your site updated, especially if you include a calendar. If you change your email, make sure to change your email links as well.

❏ **COME BACK SOON:** Give the viewer a reason to check back into your site—such as a monthly update, a promise of new pages, or useful ticker-tapes supplied by a third party (such as local weather). See the Appendix beginning on page 134 for possibilities.

have a religious, social, or political outlook to share?

Once you positively identify your audience, the rest of the conceptualization process becomes easier.

Time & Money

How much time are you willing to invest in the planning, creation, and upkeep of a website? Are you willing to go keep your site small and forego some niceties in order to get free or inexpensive hosting of your site? If you don't mind banner and pop-up advertisements appearing on your site, you may be able to get a host *without* paying monthly fees.

Overall Tone

What tone do you want to set? Is this a fun site that communicates celebration? Is it a sentimental memorial to a loved one? Or should it look professional to help advertise your home business, post your resume, or sell your home?

Keep Their Attention

Create your site as if it is a magazine you are trying to sell on the newsstand. Is it interesting to your audience? Are they going to want to log onto it over and over again to view new and old content?

Try to keep it fun and interesting. And before adding anything, filter it through the question, "*Is this of interest to my audience?*" If not, don't waste your time or their time! If it truly is only for your own benefit, use it as a screensaver on your monitor.

Developing a Navigation Plan

One of the tasks that will be achieved in your WYSIWYG type of software is a Navigation Map, assuming your site will be more than just a single homepage. The Navigation Map can take a lot of different forms, but the easiest to understand looks like an organizational chart for a corporation or the design of a family tree.

Think of the homepage as the slot for the CEO or President (or the great-great grandparent on a family tree). The homepage then links to several options, and these lead to several more, and possibly to each other.

The simplest of all website structures is a linear design. The homepage leads to page two. From there you can go BACK to the homepage or FORWARD to the third page. And on the third page, you have the choice of going BACK to the second page or FORWARD to the fourth.

You start adding complexities if you add a direct link back to the homepage from any of these pages. Still more complexity is added if the viewer can jump off the second page in six different directions: to a photo gallery, a link page, an email,

Left: The more interrelated links you include, the more complex your Navigation map becomes. Visual charts are often the easiest way to view the interrelationships. This chart is from a site created in Internet Design Shop software.

and personal pages for each child. These in turn lead to other pages, and so on. It's easy to see how the complexities of navigation start adding up.

The point of this is to have a plan, and the goal of that plan is to have the various paths make sense to your audience, including an easy way to get back to the homepage on every other page. If the visitor doesn't find it easy and obvious to access the parts of your site they're interested in, they just might not bother.

The Importance of the Homepage

Think of the home page as your "first date" with the viewer. It is the place that the all-powerful first impression will be made. Therefore, the homepage should

Edit Your Pictures!

Unfortunately, the tendency is to say to yourself, "I paid for film and processing for these 36 prints, I'm going to show every last one of them!" Resist this temptation and select only one or two of the best ones for display on your website.

And don't feel guilty. Even the best photographers in the world have to take a lot of mediocre shots to get those few amazing ones. It's perfectly okay to leave out the worst.

set the tone you want for the site. This tone should match the goals mentioned on page 86 earlier in this chapter.

In addition to the tone of the content, you'll also be establishing the graphic tone of the entire site. The color scheme, fonts, and design "flavor" of this page ideally will be reflected on the other pages, so that viewers will feel confident that they have not "left" your site as they click from page to page. Cascading Style Sheets (CSS), discussed briefly on page 84, make this easier by passing along important graphics and style information from page to page.

Integrating Photos & Memorabilia

Photos, memorabilia, videos, and graphics should also be evaluated for content and appeal before posting them to the site. A great 15-second video will have exponentially more impact than a rambling, boring, 15-minute video.

A single great photograph from an event is more powerful than including the dozens of other images (good, bad, and ugly) that you took on the same day.

Not only do the so-so images dilute the impact of the few great ones, but it takes much longer for your visitor to download a page with a lot of pictures. Remember that, even if you have a super-fast cable modem, Uncle Fred might still be using a dial-up telephone modem and it will take exponentially longer for him to view the site.

Formatting Photos for Web Usage

Once you gather and digitize your images for your website, you need to make sure they are optimized in terms of size and format. High-resolution images from a multi-megapixel digital camera or a high-resolution scan are way too big to use on the Internet.

If your photos are too big, they will take a long time to download and may eat up all of the file space you have allotted for your website.

Your goal is to resize these photographs so they are large enough to look good on the monitor, but no larger. This will keep the overall size of your site down so you can keep under your host's limits, and it will make downloading quicker for the viewer.

Most of today's computer monitors are designed for approximately 72 dpi to 100 dpi (dots per inch), which means you can use lower-resolution pictures than you would for printing the pictures. Therefore you'll probably have to resize all your pictures for web usage.

Resolution & Pixels

The key to understanding resizing your images is resolution. Resolution is expressed in terms of pixels, which are the individual picture elements that make up the digital photograph.

Resolution can be expressed in three ways:

1. TOTAL PIXEL NUMBER: One megapixel equals a picture made up of one million pixels.

2. PIXELS EXPRESSED IN TERMS OF WIDTH AND HEIGHT: An example is a 400x600-pixel image, which also totals 240,000 pixels (mathematically, 400 times 600 equals 240,000).

3. PPI or DPI: The PPI (pixels per inch) or DPI (dots per inch) can be expressed in the total number of pixels if you know the image dimensions. A 100 dpi picture at 4x6-inch size equals a 400x600-pixel image, or 240,000 total pixels.

Resizing Your Photos

To resize your digital photo, open it in photo-editing software, such as Picture IT, PhotoSuite, Photoshop Elements, or Photoshop. Next, resave the image under another name so you can retain the higher-resolution version for future

Optimizing for Web

Some photo-editing software helps you optimize your pictures for the Web automatically (without having to do it manually through the RESIZE or IMAGE SIZE functions). Check the instruction manual, or look for functions with names like OPTIMIZE FOR WEB or SAVE FOR WEB. Otherwise, you'll need to manually resize the pictures.

projects. Adding a "W" suffix or prefix to the name is a good way to indicate it is a lower-resolution web version.

The software usually has a command called IMAGE SIZE or RESIZE. It allows you to choose a size in terms of inches and dpi/ppi, or a size in pixels. An easy method is to pick the dpi (75 or 100, as mentioned above) and the approximate size you want it displayed.

I often select 4x6 inches (10.2x15.2 cm) at 100 dpi (400x600 pixels) as a starting point for a large photo for my website, and 2x3 inches (5x7.6 cm) for midsize. (Note that the exact size it is displayed at will depend on the monitor settings of the individual viewer's monitor.)

Starting with a Scanner

If your picture is not in digital form, have no fear! It's easy to digitize almost any conventional photo, artwork, or paper.

If you're using a home flatbed scanner to convert a 4x6 print for web usage, and want the image to appear approximately that size on the monitor, scan it at 100dpi and 100% enlargement (actual size). In this way, the scanner creates a digital version with a total of 240,000 pixels (400x600). (See page 28 for more details.)

Retouch, Resize & Rename Your Photos

It is always better to retouch your pictures before resizing the images. It is easier and yields better results if you correct color casts, brightness, contrast, etc. in the larger size.

Before resizing your photo for the Web, save it under a slightly different file name. This will enable you to keep the original high-resolution version for future use. If you were to save it smaller under the same name, you'd forever lose that detail.

To make identifying your images easier, spend a few moments to plan your picture names. This will save you a lot of time previewing thumbnails to figure out which picture is which. I like to use a six-letter text code based on a descriptive abbreviation. Then I can add "TN" to the end or front if it is a thumbnail version, or "W" if it is sized for regular web usage.

Once you've uploaded your files, don't change your names or it will cause confusion when you update the site. The instructions to your host are based on finding the files through elaborate paths based on folder and file names. If you change them, these paths will be broken. Viewers will see that dreaded "404 FILE NOT FOUND" error message.

Be Consistent

Keep track of your photo sizes on a notepad because you'll want to be consistent. I recommend using only two or three basic photo sizes throughout the entire website. This will help give your site a professional look.

Photo File Formats

There are several picture file formats that work on the Web. The most common are GIF, JPEG, and BMP. These are files that end in the designations ".gif," ".jpg," and ".bmp." File formats go in and out of vogue as technology and consumer preferences change. But there are several you will probably run across a lot.

JPEG

Photos are usually best saved in the JPEG format for web usage. JPEG (.jpg) is a compression file format that can be reduced to one-tenth the normal file size with minimal loss of detail. Compressed files take up less memory for storage and can be downloaded quicker than their larger non-compressed counterparts (such as TIFF).

JPEG is a good file format for photos because it supports millions of colors and can therefore appear seamless. However, it is generally not a good choice for text, line art, signatures, and sharp-edged graphics. (Select the older GIF format for these purposes.)

It is also a "lossy" format, so the more you compress it (and the smaller its file size gets), the more image degradation you will see. The good news is that you generally can't see the difference until you start getting quite small. Medium to high quality (low to medium compression ratio) is okay for most photos.

The compression option usually appears when you use the SAVE or SAVE AS function in photo-editing software. Make sure the PREVIEW box is clicked, so you can watch the quality change. Continue compressing it until you see a change in quality, then go up one "click" in quality.

GIF

GIF format is one of the oldest Internet file formats. It was started in the days of 256-color monitors and it has maintained that specification. Because "photo-quality" images are made up of millions of colors, this is not a good format for most photographs. However it is a very good format for colored graphics because of its incredibly small size.

Interlaced GIFs are just a fancier version of the standard GIF. Developed for the days of slow telephone dial-up connections, these images would appear blurry at first and gradually get sharper (as opposed to line-by-line in the non-interlaced version). Faster downloads make most GIFs appear quickly, so this distinction is no longer important to most Internet surfers.

Transparent GIFs are the equivalent of silhouetting in photo-editing software. They allow any non-colored area to be transparent instead of white, so they can

be layered over backgrounds and other photos without the box outline.

Bitmaps (BMP)

Bitmap photos were originally designed for the PC photo world. They are RGB in format, making them good for display on monitors. However, they are not as versatile as other photo formats, such as JPEG.

TIFF

The TIFF format is *not* a good format for the Web. However, it is excellent for professional printing and photographic applications and for retouching. If your digital camera shoots TIFF files or you have scanned in TIFF format, resave your images in the much smaller JPEG format for web usage.

PNG & MNG

Portable Network Graphics (PNG) is a newer, web-oriented picture format. The advantage of this format is that (like JPEG format) it can be used to save photographs made up of millions of colors, but it can be compressed without a loss of detail (unlike JPEG, which gives up some quality).

The disadvantage is that it cannot be compressed as small as JPEG, and some of the older versions of popular Internet browsers cannot "see" it. More detailed information and the most up-to-date compatibility information can be found on the World Wide Web Consortium (W3C) website at www.w3c.org.

Multi-Image Network Graphics (MNG) format is a version of PNG (above) that supports animation.

Backing Up & Organizing Your Files

Be sure to back up your files on removable media, such as a CD, Zip, or floppy disks. When you're learning new web design software, save different versions as you go along. If you find you have made a mistake, you can go back to an earlier version without having to start at zero.

This is also true when resizing images for web usage. Make sure you keep versions of them under different names so as not to lose the original high-resolution files.

Even if the original is the right resolution, I prefer to copy it into my website folder under a new name. This is so that I will have it in the same place as all my web files (the software files *and* all graphics and photographs included in the site), which will greatly simplify the process when I'm ready to go live.

Some of the WYSIWYG types of software will actually make photo galleries that allow you to view the contents of your web folders as thumbnails.

Chapter 5
Designing Your Site

The Two-Hour WebsIte

No exaggerating: The first two pages of the Smith Family website shown here were created in under two hours, using simple WYSIWYG ("What You See is What You Get") software. This includes the 15 minutes it took to doctor the lead photo in a photo-editing program (see page 96). The two pages shown here were created with VCOM's Web Easy program, but most of the software mentioned in this book (on pages 20 through 21 and in the Appendix) could have worked just as easily.

Part of what makes this website so fun is the lead photo. Not only is it a strong picture, but it works as a background as well,

REPEAT GRAPHICS

Your website will have a more consistent look if you repeat certain graphic elements on each page. Although the background changed between these two pages, the "Smiths" title, the white borders on the photos, and the nav bars make the transition smooth.

Right: The first two pages of the Smith Family website (upper and lower right) were created in under two hours using a simple WYSIWYG type of software (in this case, Web Easy).

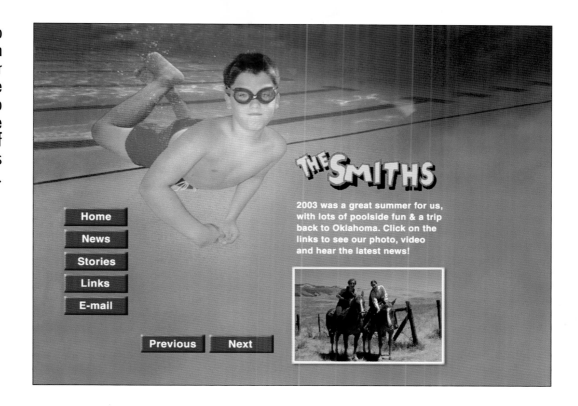

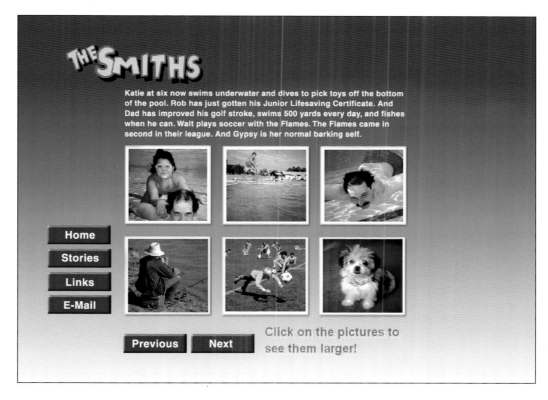

because of all the "empty" space in the picture (the blue water) over which you can put type and pictures. Designers call this "negative space."

On page two, I could have repeated the same background, but that would have been overkill. So instead, I opted for a graduated blue background selected from the standard web palette. It doesn't match exactly, but it's pretty close.

Improve the Image

This underwater shot of the swimmer was taken with a waterproof, one-time use (disposable) camera. It was shot a little off-center, which gave me the idea of using it as a background for the site because of all the "empty" space in the lower right—perfect for overlaying other elements.

THE STAMP TOOL

Most quality photo-editing programs offer a control called STAMP or CLONE or something similar. Use this tool to quickly replace unwanted items from the background with tones copied from elsewhere in the photo. It's also great for retouching skin blemishes.

In Adobe Photoshop Elements photo-editing software, I increased the CANVAS SIZE and filled it with blue color copied (STAMPED) from the water. This STAMP tool simply copies a small portion of the picture that you "sample" by clicking the mouse, allowing you to "rubber stamp" it elsewhere in the picture. In this way, I enlarged the off-center blue section, and evened out the color. The color in the photo was also improved by removing some of the green cast in the swimmer's skin and bumping up the contrast.

GIF headline for "Smith"

The Smith headline is not a font installed in most computers. So some of the two hours went into creating a GIF graphic so it could be loaded like a picture.

I used clip-art letters from an inexpensive clip art combination book/CD.

1

2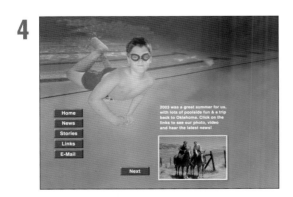

3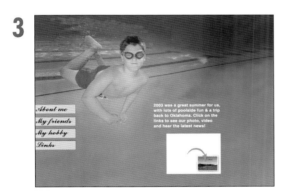

4

The individual letters loaded as separate pictures, and I moved them around in graphics software until they lined up just right, and then saved them as one picture. I could also have created this in photo-editing software that allows the combination of several images (i.e., the individual letters), or made something similar (but not exact) in Microsoft WordArt (see page 33).

The final product was saved as a GIF because this is the most efficient format for graphics with simple colors. (JPEG is best for photos with continuous tones.)

Start with a Template

The black template at left was actually the starting point for the Smith website. I simply chose one of the dozens of templates that came with the software, knowing I could quickly customize it. This template supplies fake type that you can replace, and a gray "placeholder" for the photo of your choice. The process is as follows:

1. I deleted the "About Me" background and replaced it with the underwater photo.

2. The photo was too large, so I went back to the photo software and resized the image exactly. This saved overall file size and gave it the cropping I wanted.

3. I moved the gray placeholder photo to the bottom right by dragging it with the mouse, then clicked on the text box and resized it so it no longer cut into the "live" image area (the boy).

4. I selected navigation buttons from the clip art files that came with the software.

The titles of these bars (HOME, NEWS, STORIES, LINKS, EMAIL, NEXT, and PREVIOUS) fit my needs. The deep red color also picked up the swimsuit color on the homepage and stood out nicely from the blue background on all the pages.

5. I changed the text to include a headline and body type for a newsletter look.

I also found the second swimming image to be too much of a good thing. Instead, I opted for an inset photo with totally different subject matter—a horseback riding trip on the range in Oklahoma.

The diamonds on the edge of the photo are the cropping and positioning tools. These tools allowed me to grab a corner diamond and resize the photo, or a side/top diamond and shrink or stretch it.

6. I added the "Smiths" graphic as a photo. (See page 96 for information on how it was created.)

7. I went back and added the word "The" to the headline so it would read, "The Smiths."

The Second Page

Unless you're doing a single-page website, you'll want to create additional pages. These pages should be graphically tied to the homepage, but need not be exactly the same. Think of them as an echo of the first—you can tell it's the same voice, but just altered a little with each repetition.

Start the second page by copying the homepage. This will insure that the

navigation bars are in the same place and they won't "jump" as you go from page to page. (This problem won't occur if you used the more advanced FRAMES or CASCADING STYLE SHEET structure.)

I chose to delete the background photo on the additional pages because it was too restrictive graphically. Instead, I

5
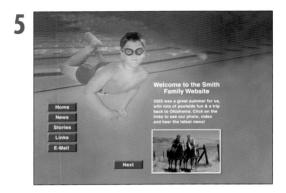

6
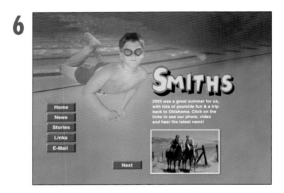

7
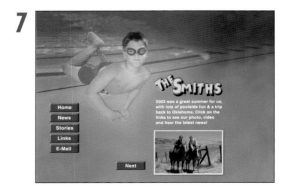

Page Two Should Reflect the Homepage

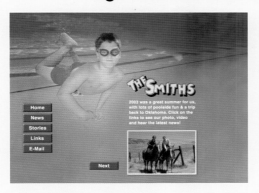

1. Start Page Two by making a copy of the homepage.

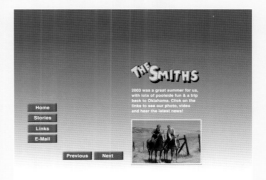

2. Delete the photo background and add a gradient blue that matches the water.

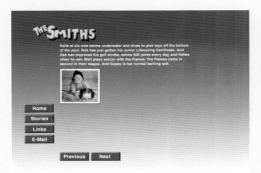

3. Move the Smiths title graphic, the photo, and the text.

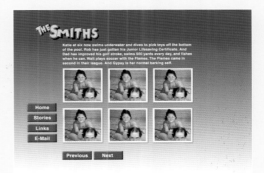

4. Repeat the photo five times and add yellow type.

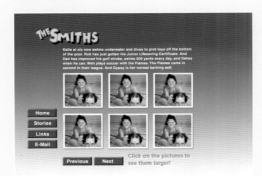

5. Make a GIF of the red/yellow type.

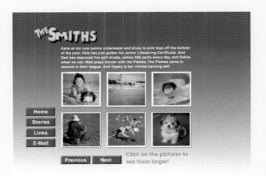

6. Replace the photos with new images.

replaced it with a gradient blue that echoed the colors in the homepage photo. I then dragged the other items around the page with my mouse. Clicking on the individual items allowed me to resize them at will.

The single small picture was then copied to create a total of six small thumbnails.

Yellow instructional text ("Click on photos to enlarge") was added. The yellow text was too hard to read, but I liked the way it picked up the color in the Smith headline.

In photo-editing software, I made a yellow text box. Then I copied it and changed the second version to red. I placed the yellow layer over the red, but slightly askew, and then saved the result as a GIF and imported it to the page.

For the final version, the six photos were changed. Step two was to link them to enlarged versions so the viewer could click on them to see them larger.

The Linking Stage

Now that the graphics had been designed, I could begin the linking stage. Each WYSIWYG software package handles this differently, but the concepts are the same. In short, you can identify a text or graphic element (usually by clicking on it with the mouse) and tell it to link to other items.

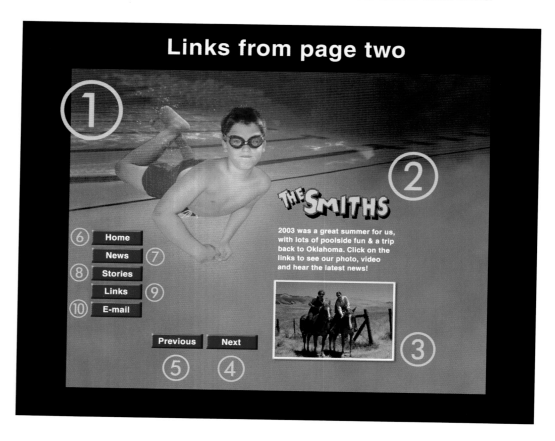

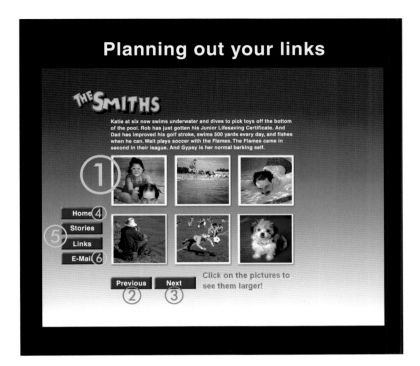

Planning out your links

THE SMITHS

Katie at six now swims underwater and dives to pick toys off the bottom of the pool. Rob has just gotten his Junior Lifesaving Certificate. And Dad has improved his golf stroke, swims 500 yards every day, and fishes when he can. Walt plays soccer with the Flames. The Flames came in second in their league. And Gypsy is her normal barking self.

Home ④
⑤ Stories
Links
E-Mail ⑥

Previous ② Next ③

Click on the pictures to see them larger!

Above & Left: Planning out the links for your site is a very important step in building your website. See the text for details.

In the example of the Smith Family homepage (page 95), many different links could be created (or not).

① The swimming boy photo is the background and need not link to anywhere.

② Although the "Smiths" headline is actually a GIF image, it does not logically lead to a link.

③ This photo would be a logical link to the news section, a gallery about the trip, or a larger version of the picture.

④ ⑤ The NEXT button will lead to the page *you* want the visitor to see next (in logical progression). The visitor is free to use the navigation buttons on the left to go where she wants, but you can set the preferred linear order through the NEXT and PREVIOUS buttons.

⑥ Since this is the homepage, the HOME button can be eliminated from this page or simply made inactive.

⑦ ⑧ The NEWS and STORIES buttons should be your most commonly updated section of the site, with the latest events depicted in words, pictures, or videos.

⑨ LINKS can be to other sites of interest to your family, such as the kids' school and sports teams, organizations you support, or favorite hobby pages.

⑩ The EMAIL button will open up an email letter, pre-addressed to you.

Second Page

The links don't stop with the first page. The same set of decisions must be made on the next page.

① The six thumbnail photos can individually link to a larger version of the picture or jump to a gallery of related thumbnails.

② ④ Because this is the second page, the PREVIOUS navigation bar on the left will take the viewer back to the homepage, as will the HOME button.

③ The NEXT button will lead to the STORIES page, which is next in linear order.

⑤ The STORIES navigation aid goes to a page celebrating the latest events. The LINKS jumps to a page full of links to interesting or related sites.

⑥ The EMAIL button will open up an email letter, pre-addressed to you.

Family News Reporting

Family news reporting can take many different forms, from a traditional newsletter format to fun and innovative "new baby" announcements of all types.

Sharing News

Probably the number one reason for starting a family website is to share news. You can announce your proud family events, from the birth of your child to the highlights of your summer vacation.

You can keep loved ones informed by uploading up-to-the-minute news and photos on your website. You can even do it while on vacation. Family all over the world can click on and watch a video of your newborn from the comfort of their home! And if you have a digital camcorder or digital camera with "movie" capability, they can do it minutes after you shoot the footage.

Newsletters are a fun way to spread news, by mimicking a newspaper. The newsletter below was created from a simple template in VCOM's Web Easy software, but most WYSIWYG software have templates you can use, as do many hosts that include online software. If your software or host doesn't have a newsletter template per se, simply use the headline type to name it *The Smith Tribune*, *The Jones Herald*, or *The Bidner Journal*. Then, use text boxes and picture boxes to create the stories.

Family Achievements

There is no better way to bolster your kids' confidence than show your pride in their achievements. The family website is a

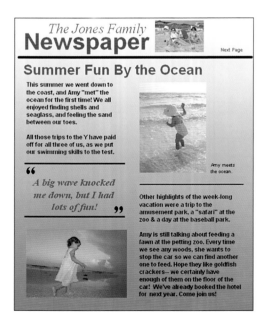

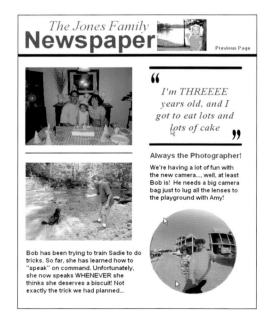

Left: You can be very literal and create a family news site that looks like a newspaper or newsletter, even naming it the *Jones Journal* or the *Smith Tribune*.

A Comparison of Two Homepage Designs

These two homepage designs have the exact same elements and basic text. However, the bottom one has a more lively feeling. One of the main differences (aside from the background colors) is the blocky design of the first one. It is very gridded, with all elements lined up and the photos the same width.

To improve the design, the first major change was to make one of the images more prominent (the historic shot, to which an artistic border was added).

The navigation bars on the left were simplified to just text (rather than red buttons), and the section was offset from the main text with green.

The font for the headline was changed to a lighter style, and the headline was allowed to cross into the new green area to help join the two colored portions.

The other three photos were cropped even further, leaving only a hint at their content.

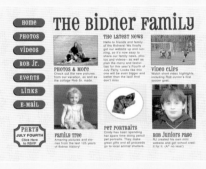

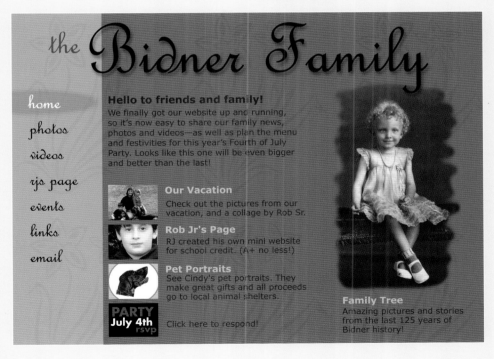

great way to recognize their academic, sports, and extracurricular achievements. Good visuals include photographs, stories, report cards, artwork, merit badges, awards, and even a school term paper with the cover and the teacher's "A+" mark scanned into a digital picture.

Celebrating a New Baby

The best excuse to start a website is the arrival of your baby. You can prepare the site ahead of time by designing it but not uploading it to a host for publication. Just leave the vital statistics blank (or write "info to come") and put in an empty photo box. Then, after the baby's arrival, you can upload the missing information and photos and you're ready in minutes!

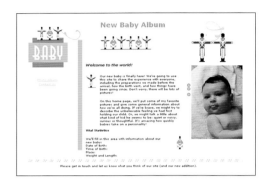

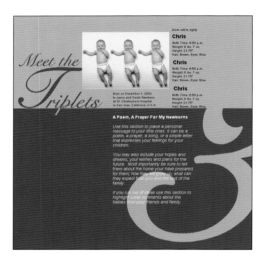

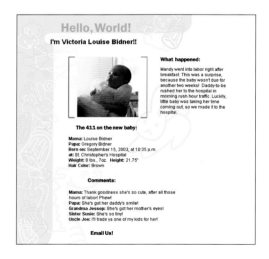

Left: Newborn announcements are a wonderful use for family websites! Many online and standalone software packages offer easy templates, such as the top two from Tripod and the remaining three from Geocities.

Tips for Photographing Infants & Toddlers

Pictures of your kids can be one of the most important elements in your family website. Here are some tips that will help you get great photos of them.

BABY PICTURES

1. To get attractive eye-level portraits of an infant, photograph the baby in the parent's arms or a car seat. Surround them by an unpatterned or simple-patterned blanket. White or soft colors are good and lend an "angelic" look.

2. Look for soft light, such as a window with north light.

3. Use the camera's zoom to crop out distracting elements. Then, wait patiently for the perfect expression or recruit a family member to try and coax a smile.

TODDLER PICTURES

1. Photographing a toddler is difficult because your little subject is probably always on the run. Your best chance is to become practiced enough to know your camera's settings by heart so you are prepared to act quickly to get the picture you want.

2. A good trick is to photograph toddlers when they're engrossed in an activity and unaware of the camera.

3. Again, you'll generally get the best results if you get down to the child's eye level to take portraits.

Near Right: Getting down to your child's eye level produces a much more intimate portrait.

Far Right: A good portrait technique for infants is to place them in a car seat and snuggle them into a neutral, unpatterned blanket.

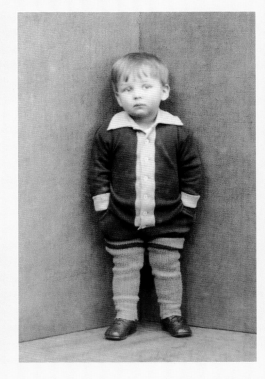

You may find the most variety in templates available in software and from host companies in this "New Baby" category. There are options for new adoptive parents, as well as birth announcements for both sexes, twins, triplets, and even larger multiple births.

You can also create your own design from blank pages, such as the very simple "pictures of me" design below. All you need is a some baby clip art, some cute page names and a photo, footprint, or other piece of memorabilia. You can write the site in your own voice as the proud parent introducing your new child, or in the child's own "voice" (as in, "my little feet").

Companies such as www.babababies.com offer free online birth announcements and secure websites for kids. Several companies, including www.MyFamily.com specialize in private family websites.

Left and Above:
You can get very creative in what you include in your newborn's website. The yellow site was created from scratch using WYSIWYG sofware.

Personal Pages

"About Me" pages are a popular way to network. Some colleges use them as a way for classmates to learn more about each other.

They're great for people wanting to meet new friends, other hobby enthusiasts, or even prospective new love interests.

Some hosts with Instant Messaging or similar instant dialog capabilities can include a click box that lets your visitors know if you are online at the moment and available for instant messaging.

Weblogs & Diaries

Online journals and diaries are an increasingly popular form of literary, political, or religious expression.

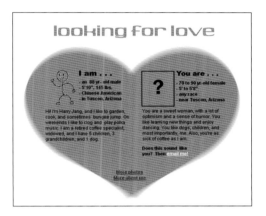

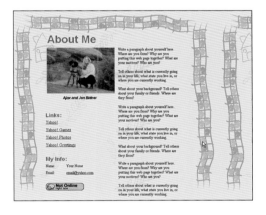

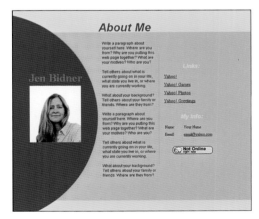

Right: Personal pages have become a increasingly popular way to make new friends, find fellow hobby enthusiasts, or even search for your soulmate. These pages were created in just a matter of minutes from templates supplied by an online host (Yahoo/Geocities, in this case).

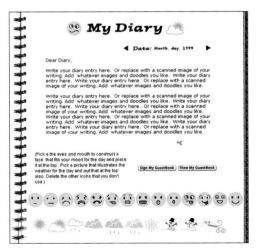

Kids' Pages

Creating the family website can involve the whole family. Not only does it become a fun family project, but encouraging the kids to join in and create their own pages is a great way to build self-esteem.

Your children can record their activities, showcase their photos, and communicate with friends. Simple steps can be taken to password-protect the site so only friends and family have access (see page 14).

Kids' pages can be integrated into the family site as individual pages, or each child can have his or her own domain name.

Depending on the age and maturity of your children, they can get involved at all levels. At the simplest level, they can help pick the photographs, draw original art, or even take snapshots for the site.

Special Projects

You can create some wonderful educational projects with your children. If your daughter is a budding naturalist, you can encourage her to be a wildlife sleuth in your backyard or a public park. Ants, butterflies, squirrels, and birds are found even in the busiest city. And there is always the possibility of a trip to the zoo.

Visit the Animal Planet website, the local zoo's website, or a conservation group's, and see how they explore the world. Can you and your child develop something as interesting and fun to visit? Depending on her age, you might have to help with setting up

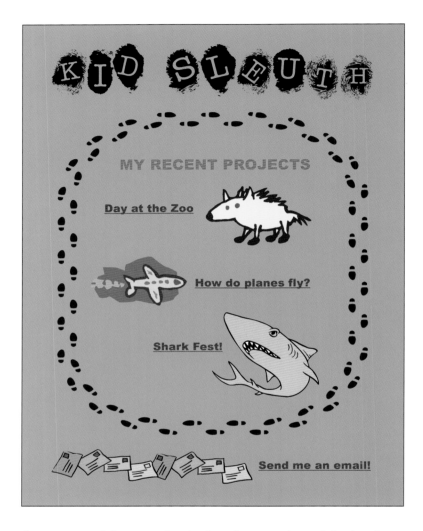

the structure of the site and uploading, but even a kindergartner can help with content.

She can take pictures of the different animals or pick up clip art photos of the species, and then write an essay on her observations. You can build inexpensive ant farms and butterfly cocoons and study the habitats. Internet research on the subjects can add to the information. Links to other related sites can round it out.

Above: School and home research projects and trips can be turned into a creative website using words, pictures, and clip art cartoons.

Too much like school? Make it more fun by encouraging your daughter to showcase the original fashions she designed for her Barbie dolls. Or, lend the digital camera to the twins so they can write and photograph a cartoon with their toy soldiers or action heroes as the main characters.

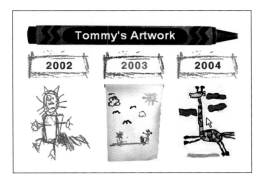

Junior Photographers

Photography can be a fun hobby for kids, and posting the images to the family website is a natural progression. An inexpensive digital camera is great for the task because you won't need an allowance for film and processing—but you will need to discuss a "budget" on the inkjet paper and supplies they're bound to use.

Young Photojournalist

When it's one sibling's big day (a birthday, sporting event, or recital), you can keep the other siblings involved and occupied by asking them to play the role of journalist or photojournalist. They'll be tasked with the very important job of documenting the day for the website.

Security Considerations

Anytime you put information about or by your kids out into the public domain, you need to take precautions. I highly recommend selecting an Internet host that allows you to password-protect your site so only trusted family and friends can access it.

Free and inexpensive family- and kid-oriented hosts include EduHound.com, MyFamily.com, and EZkidWeb.com. A Spanish-language version is even

available from EduHound. And family-run projects like Awesome Clipart For Kids offer collections of free children's and educational clip art and animations that your kids can add to their site.

At the very least, make sure only first names appear, and that the names cannot be linked to a home or school address. Don't forget your domain name may contain your last name, or its registration might be under your family name. If you want to keep your child's last name unknown, consider buying the site name registration under a company that does domain registration by proxy. See page 14 for more information on security and privacy.

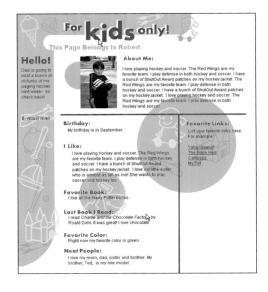

Right and Upper Right: There are plenty of easy templates for kids' sites (at right, from Geocities), or they can build their own from separate elements (above, from Homestead).

School Activities

Individual teachers, the entire school, or the Parent Teacher Association (PTA) can set up websites with relative ease. Teachers can list homework assignments, calendars of all types, classroom supplies needed, field trips, lunchroom schedules, and more. The PTA can post their calendar, discuss upcoming proposals, or introduce new candidates for the board of directors.

A wisely planned classroom site can allow parents to quickly check on homework assignments or get makeup assignments should their child need to miss school. Study aids can be posted, should the students (and parents) need extra help on the homework assignments.

Calls for parental involvement ("parents' homework," like reading to the kids or practicing spelling lists) can be posted, as can requests for donations or special volunteers. Likewise, parents who volunteer

to help chaperone on field trips or work as lunchtime monitors can be acknowledged for their efforts.

And don't overlook the site itself as an educational project for the students. The

Below & Left: Self-portrait drawings of the students are endearing as well as more secure than using photographs.

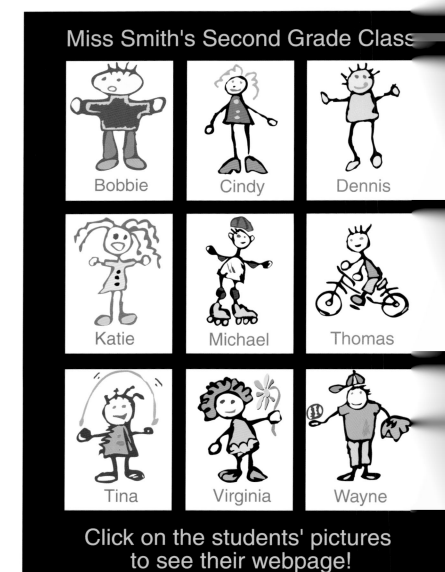

HOME
STUDENT PAGES
 BOBBIE
 CINDY
 DENNIS
 KATIE
 MICHAEL
 THOMAS
 TINA
 VIRGINIA
 WAYNE
REPORT CARDS
HOMEWORK
LUNCH MENUS
FIELD TRIPS
VACATION DAYS
READING LIST
EMAIL MISS BIDNER

My favorite sport is kick the can.
My favorite color is yellow like flowers.
I have a big sister. she is nice.
I don't have any pets.
I really want a white rabbit!
Math is my favorite subject at school.
When I grow up I'm going to have a farm and raise rabbits so every kid can have one.

Miss Smith's Second Grade Class

Bobbie Cindy Dennis
Katie Michael Thomas
Tina Virginia Wayne

Click on the students' pictures to see their webpage!

Miss Bidner's
second Grade class

TIC, TAC & TOE
Meet our class
pets & read
stories about
them

FUN SCIENCE!
Explore the
science of
amusement
parks

OUR EARTH
Essays on the
earth, space,
& astronauts
by students

GOING BATTY
Class research
on bats—just
in time for
Halloween!

OUR CLASS
The students
created their
own web pages
& self-portraits

Near Right: A teacher's website can also be a class project, with students doing research, writing stories, and designing their own pages.

Far Right: Educators can link classrooms around the world and share their knowledge with students outside their own classroom.

class as a whole can do research reports and then put together an online newspaper reporting their results.

Security Issues

Teachers will want to keep security and privacy in mind when creating their websites. Only the first names of students should be used. "Self-portrait" *drawings* are recommended rather than photographs. Not only is this smart from a security standpoint, but it's also cute!

Many hosts allow passworded log-ins so parents can access private sections, such as their child's report card or a written progress report. Likewise, the *entire* site can be password-protected, with the password given only to the parents.

Check out hosting companies that are dedicated to classroom websites, such as MySchoolOnline.com. Not only are they relatively cost-effective, but they have easy web design templates and clip art geared toward classroom sites. The whole school can join, or just an individual educator or Parent Teacher Association.

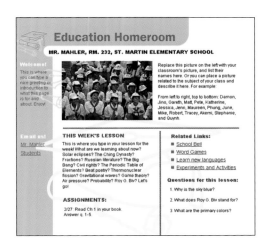

Genealogy & Family History

The shoebox full of old pictures or the stack of disheveled albums is no way to showcase your family's historical photos. It's also difficult to make sense of the interconnections when viewing a stack of pictures. Genealogy sites can help.

A genealogy website has two purposes. It's an online album that can be viewed by distant relatives, and it's a way to collect contributions (photos and stories) from distant relatives.

Start by scanning your own historic prints. (See the section on scanning on page 28.) Then recruit distant family members to add their pictures.

Tracing your roots is easier in the computer age. There are hundreds of websites that will help you get started in basic genealogy and dozens of software programs to choose

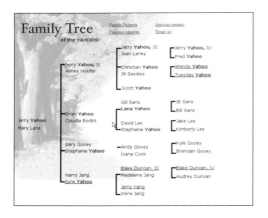

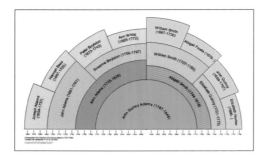

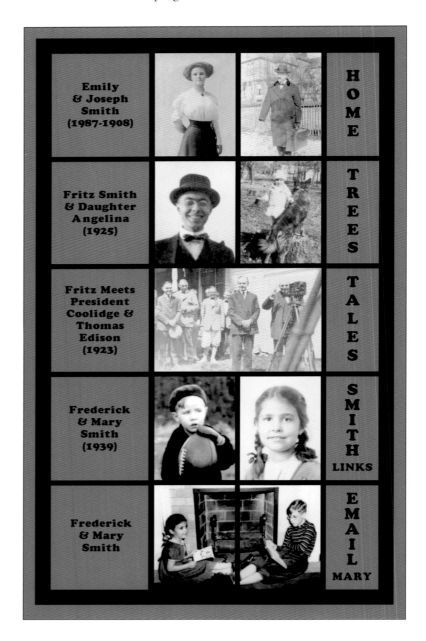

among. When selecting software, look for the following options:

1. A program that easily integrates photos (rather than just names) when you build a family tree chart.

2. Only a few genealogy programs are Internet-ready, so read the specifications carefully if you just want to click and add a family tree to your site.

3. Some programs allow you to save the tree as a JPEG, which can be imported to your site like any other photo.

4. If worse comes to worst and you like everything else about the program, you can print out the tree, scan it, save it as a JPEG, and import it to your site.

Organizing the Site

You're not stuck with just doing a "family tree." You can build the site in a more journalistic fashion or as a photo gallery.

Ideas include dividing the sites into categories, with quick navigation aids to these sections. Options for categories include: generations (listing the head of household), decades (or even centuries), parts of the world, or alphabetical order.

You can add a guest book on your site for family visitors to add their own stories about family history. Or, you can solicit the stories and photographs via an email list and edit and post them yourself.

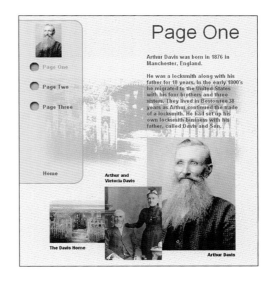

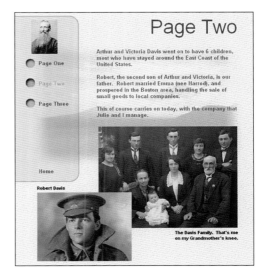

Vacation & Travel Logs

The family vacation is one of the most memorable events you'll share together. We abandon work to relax, travel, and have fun. It's also something that your friends and relatives will want to share with you.

You can create a page or gallery of pictures from the trip when you get home. Or, if you have a laptop computer and a digital camera or digital camcorder, you can update the site while you're on vacation. Think about how much Grandma would enjoy logging on each night to see pictures or a video clip of the day's activities, not to mention how jealous your pals at the office will be!

Even if you don't have a laptop, most communities and foreign countries have "Internet cafes" or Kinkos-type businesses that enable you to quickly upload your digital pictures to your site from thousands of miles away.

Far Left: Travel templates from Lycos/Tripod allow you to quickly build a vacation or travel site.

Near Left: Your vacation videos and photos can be featured on a website of their own or as one page in your main site.

Below: Today's technology makes it possible to update your website *during* your travels, so friends and family can "travel" along with you in almost real time.

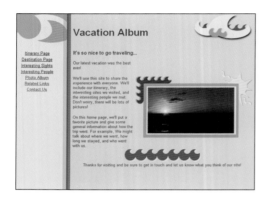

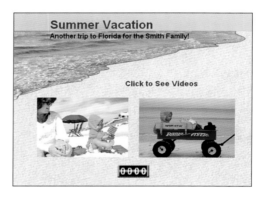

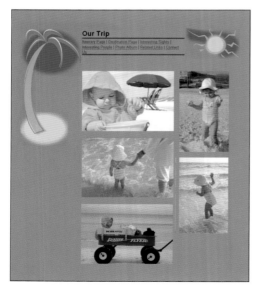

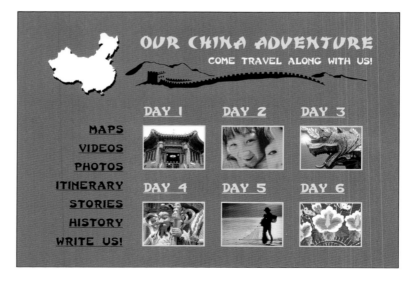

Great Vacation Photos

First and foremost, your vacation photos should tell the story of who went on the trip, the fun you had, and the wonderful things you did and saw. Plan on taking several types of vacation photographs.

DESTINATION PHOTOS: Try to find scenic views, cityscapes, or monuments that illustrate the beauty and unique features of your destination.

WE WERE HERE: You can buy a postcard of the Great Wall of China, but a picture of you or your traveling companions walking along it is a much more memorable souvenir. You can use a tripod and self-timer to include yourself, or you can ask a stranger or tour guide to click the shot so that the whole family is in the picture.

CANDIDS: You might get so caught up in the scenery that you forget to take candids of the kids and your spouse enjoying their vacation. Don't! These might be some of your most memorable pictures from your vacation.

CULTURAL SLICE OF LIFE: If your destination is exotic, the cultural differences can be shown in pictures. Just the daily shopping rituals in a foreign country can be fascinating. And a scenic boat, plane, or helicopter ride can take you to areas inaccessible by roads.

Photography Gallery

Whether you shoot film or digital pictures, it's easy to upload your images to a website and create a gallery that friends and family can view. Chapter Two gives you hints on "digitizing" your prints and film as well as improving your photography. Once your photos are in digital form, you can present them on a website. There are numerous ways of doing this, including thumbnail galleries, traditional slide shows, or virtual albums.

Thumbnail Galleries

The thumbnail gallery is an efficient way of presenting your pictures. The concept is that you show postage-stamp sized versions of the photos (thumbnails) on the page, with each one linking to an enlarged version (with or without a caption). This link can be in a new window (like a pop-up) or simply as the next page in the same window (requiring the visitor to click BACK to get to the gallery again).

The beauty of thumbnails is that they are so small, they load quickly. The viewer can then judge from the small version if they want to see it in its full glory, and spend the time to enlarge it.

The time savings are all for the visitor, because it can take a quite a bit of work to build a thumbnail page. Twenty thumbnails must link to 20 different pages, after all. If your software does not have a template for thumbnails, try adding a TABLE. Then in each cell (the individual compartments created by the columns and rows) you can add a photograph.

Right: The artistry you brought to your photos should continue into your website. Using the text and visual elements, you can create an endless number of styles and looks for your website.

Left: Thumbnail photo galleries are a great way to preview photos, so your visitor can scan the small images and then click to enlarge the interesting ones.

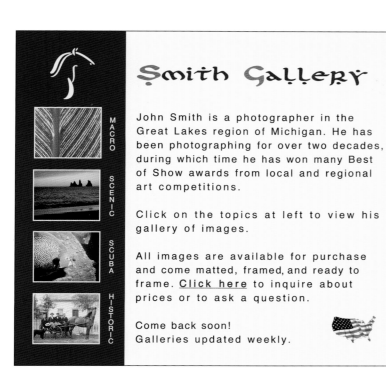

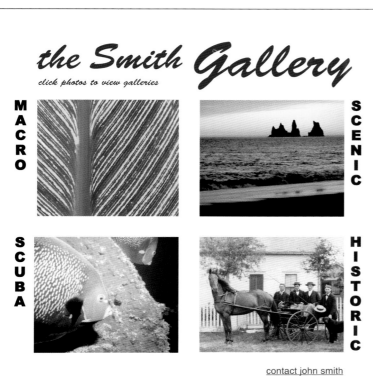

contact john smith

Subjects & Categories

You can also organize your photographs by categories or subjects, such as family, fine art, nature, and travel photography. Once the visitor chooses her preferences from a text or thumbnail photo list, the site can present thumbnails or slide shows (see below).

If you're showcasing family photographs, I highly recommend doing them in reverse chronological order. In this way, repeat visitors can quickly see if there is anything new on the site without having to scroll though the old options first.

Slide Shows

There are simple JavaScript applets available for slide shows, where a picture box appears on the page (often decorated like a TV set) or a separate window pops up for the images. You can allow the visitor to click through the pictures manually (hitting the NEXT or BACK buttons), or you can have them rotate automatically.

This box can be very decorative, as in the choices offered with the online site-building software on Homestead.com. Or, it can be simple and borderless.

Virtual Galleries

A relatively new way to present your photos is the virtual album or virtual gallery. FlipAlbum software allows you to insert your pictures into virtual albums. The viewer gets to "turn the pages" of a three-dimensional graphic of a photo album, with page-turning sound effects and all.

The professional version of FlipAlbum (E-Book Systems) is web-enabled, so

Left: Virtual galleries create a virtual world in which you can view your pictures on the wall of an art museum or watch them rotate and dissolve in exciting patterns. These two examples are from 3D-Album software.

Left: Virtual albums allow you to "turn" the pages and view the album. The professional version of FlipAlbum, shown here, allows you to post these albums to your website.

you can insert it into your website (assuming your host's software enables such additions).

3D-Album (Micro Research Institute) also gives a three-dimensional presentation, but it is more like a computer game in which you walk through realistic or surreal galleries and landscapes, where your images are posted on the wall or on billboards.

PhotoStory (SimpleStar) software helps you turn your still digital photos into an MTV-like music video presentation.

Lower Right & Below: A bouquet was placed on a flatbed scanner to create a digital "picture" of it. Then it was altered in Photoshop to 35% opacity and it was used as the background for the main wedding page.

Online Wedding Album

A great way to share your wedding is the online wedding album. If a professional photographer shot your wedding pictures, make sure you get permission before posting the images as there may be copyright issues and reproduction/usage restrictions.

However, if you get permission or purchase a CD from the photographer for this purpose, you can create a memorable site. Thumbnail galleries, slide shows, virtual galleries and albums, or virtually any photo-oriented design can be used.

Don't forget to include memorabilia as well. Scan your invitation, ceremony program, and congratulatory letters from loved ones.

You can even place the bridal bouquet directly on the scanner to make a digital "picture" of it. If you do this, drape the veil, an embroidered portion of the dress train, or black velvet over the flowers so the background will be more attractive.

Hobby Pages

Sharing your knowledge of a sport, craft, or other hobby can be almost as much fun as the hobby itself. Consider a website that documents the work you've done on your custom hotrod. Share your favorite recipes. Trade needlepoint designs or quilting patterns. Showcase your baseball card collection and list which cards you are willing to trade and the ones you're are looking for. Or, post a research project that you or your child has completed.

Your hobby site can be a celebration of your accomplishments or it can be a great way to teach others. You can write how-to pieces, show step-by-step progressions in digital pictures, or simply help people with similar interests learn more by providing important links to other sites.

Don't forget that you can scan sketches, blueprints, artwork, or awards for inclusion along with any before and after photographs.

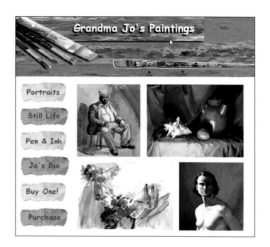

Left: Your art work can be presented for visitors to view and perhaps even purchase.

Links Pages

One of the most helpful things you can add to your hobby-related site is your research into other Internet sites. You can do this by creating a page on your site called LINKS. There, you can provide lists of other site names with a hyperlink to them.

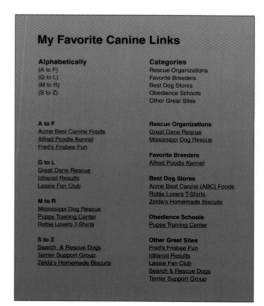

Near Left: LINKS pages are a great way to help visitors with similar interests. It is also a good way to help publicize your friends' sites, and vice versa.

Far Left: Have some fun sharing your knowledge by giving your site the feel of an "advice" column from the newspaper.

It is even more helpful if you include a short description of the linked site, so people won't waste time if they're not interested. You can list them alphabetically or by subject category.

Be sure to check these links often. If the owner/designer of that site changes her website name or deletes the page, the person who clicks on the link will get an error message.

Good pages to link to include Internet retailers (E-tailers) who sell hard-to-find tools and supplies related to your hobby. If they have an affiliates program (see page 131), you can earn commissions if your visitors in turn link to the store and end up buying.

This Page: Your collection of historic images—or your favorite historical subject—can easily be turned into an interesting website. Be sure to write your METATAG titles and descriptions carefully if you want the site to be picked up by search engines.

The History of AMERICAN Search & Rescue Dogs

By the turn of the century, Americans were well-known for their tracking dogs. Unlike the English bloodhound that worked on-lead, some American dogs were often let loose in packs, with the handlers following on horseback. This allowed them to quickly cover even the roughest country.

By the early 1900s, these dog packs were a common sight at prisons or guarding work camps. The system had its historic roots in the Southern plantations, where they were used to track down runaway slaves.

Despite a strong history of police and prison dogs at the turn of the century, the U.S. did not have an official war dog program until 1944.

Ambulance dogs located the wounded on the battlefield

By 1900, European armies were using dogs to help stretcher-bearers find the wounded on the battlefield. These dogs would usually work off-lead and remain with the wounded man and bark an alert, or bring back a hat or other token of their find, or simply return to the handler and run back and forth between the two.

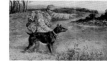
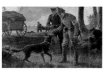

The New York State Police and their dogs, c. 1919

Man has relied on the scenting capabilities of dogs for centuries

History and literature record the deeds of war dogs as early as 2500 years ago, both as fighting troops and as sentries who scented distant enemies.

Pet Websites

Whether Fido and Fluffy are National Champions on the dog and cat show circuits, or simply the family's couch potato pets, it can be fun to create a site (or a page on your site) for them.

Celebrating Family Pets

Pets are family members, so why not give them their own page? You can write the text in the first person (the pet's voice, as in, "I am Fido"), in your own narrative, or in the third person.

The basic design principles and ideas for family and personal sites are the same from personal sites to photo gallery options (see pages 116 through 119).

Breeder or Rescue

If you are a breeder, you'll want to include pictures of the parents, the pups or kittens, and a page for the pedigree chart. You'll also want pictures that showcase the strengths of the animal, such as its great socialization (snuggling with the kids), athletics, and specialized skills, such as hunting, showing, and obedience.

A JavaScript database will allow you to collect information from prospective clients. A prompt asking them if they'd like to be notified when you have a litter of prize Siamese kittens can help you create a great mailing list.

Rescue organizations can also show pictures and provide adoption information on animals in their care.

Below: Showing the friendliness of the dogs is a great way for kennels to sell puppies, and for rescue organizations to place dogs in adoptive homes.

Lower Left: "About Me" homepages can also be created for your pet. The template here is from Geocities.

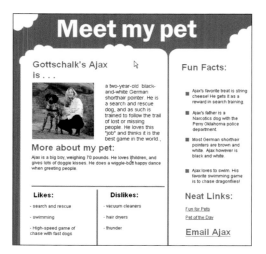

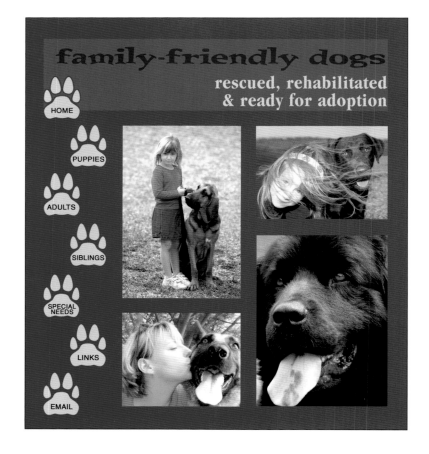

Tips for Photographing Your Pet

TAKE CANDIDS: Most animals are creatures of habit, which makes candid photography easier. Look for patterns in their daily rituals that you can predict and plan for. Or, wait until the animals are distracted in play with each other or a family member.

FILL FLASH FOR PETS: Fill flash can greatly improve pictures you take of your animal in bright, sunny situations. It fills the shadows on the animal's face and has the added benefit of brightening the color of their feathers or fur.

DARK OR BLACK ANIMALS: Most of your pictures of your black dog or cat probably either come out bluish or without any details in the fur. If your camera has exposure compensation, set it to -1 if your dark pet fills the frame. Try and place the animal in the sun so the fur picks up highlights, and turn on your fill flash, whether indoors or in the sun.

WHITE OR LIGHT ANIMALS: Frame-filling pictures of mostly white dogs, cats, mice, or birds can turn out bluish (underexposed) unless you use exposure compensation of +1 or more.

IT'S ALL IN THE EYES: Concentrate on your pet's eyes. First, start by getting down to your subject's eye level. Since you probably are taller than the animal, kneel or lie down. If the pet is small, it can sit on a table or lap. Try for direct eye contact or eye contact between the pet and its owner, showing their bond.

Lower Right: Look for interaction between the pet and it's owner.

Below: Black animals are especially difficult to photograph well.

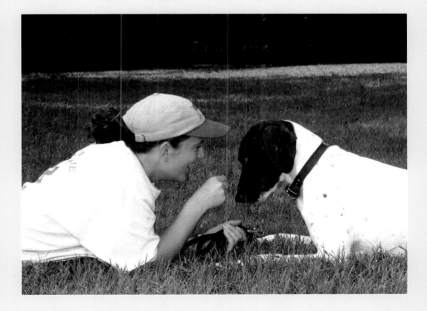

Clubs & Sports Teams

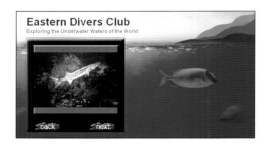

Are you coaching, or helping to organize your kids' sports teams or your own club activities? You can use your website to list schedules, give driving directions, organize carpooling, and coordinate logistics.

Galleries can showcase photographs of the participants involved in the activity.

Sports & Action Photography

Sports and action photography is one of the most difficult types of photography to do well with a point-and-shoot camera. However, there are a few tricks that will help you get good results with any camera.

SHOOT MORE PICTURES: With a digital camera this is especially true, since you don't have to pay for film and processing. But even with a film camera, plan on shooting a roll to get a few really good shots. Then throw out or delete the out-of-focus, blurred, or missed-action shots.

FAST FILM: Load faster film (a higher-number ISO) for sports. For outdoor sports, you should use at least ISO 400 and probably ISO 800 film. For indoor sports, use ISO 800 film. Some digital cameras have equivalent ISO settings, which you can set to the highest-number ISO.

CROP & ENLARGE: You may not be able to get close enough to the action to fill the viewfinder with your sports star. Don't worry. Shoot it wider and crop it later in software, or while scanning the print.

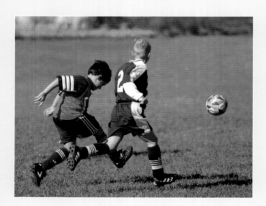

Far Right & Far Left: Your club can use a website to notify members of events, showcase their activities and photos, or solicit new members. Both these websites (designed on Homestead) feature interactive slide shows.

You can track a team's win record and the individual members' stats. You can include lesson plans or coaching tips. And don't forget links to related websites, such as professional sports teams or local associations.

And, by joining affiliate programs of companies that cater to your specialty (see page 131), you can even earn money for team or club activities.

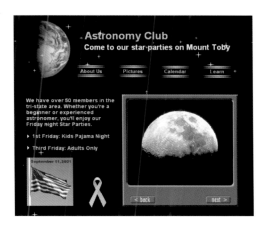

EXPOSURE MODES: Some high-end cameras have an Action Mode, usually indicated by an icon of a running figure. This mode will give you the best chance of "stopping" the action with a fast shutter speed.

PLAN AHEAD: You'd be surprised how many times you can predict where the action will be. In track and field, it's easy—there are lanes, finish lines, hurdles, etc. Use the Focus Lock function (push the shutter halfway down and hold it) to pre-focus on the spot where the action will be happening. Continue to hold the button until your subject arrives. Then depress the shutter the remainder of the way at the height of the action. This will prevent you from missing the shot while the autofocus (which is slow on some cameras) performs its function.

PANNING: One of the problems with point-and-shoot cameras is that they have relatively slow shutter speeds. Sometimes you just can't get a fast enough shutter speed to freeze the action. Instead, try the panning technique in which you follow a moving subject with the camera before, during, and after shooting the picture. The trick is to keep the subject in the exact same spot in the viewfinder (or monitor) as the subject moves. The result is a blurred background but a *relatively* sharp subject that communicates the feeling of speed. The more blurring, the more abstract the end result.

Reunions, Parties, & Events

Pulling together a major family event can be difficult. If you're smart, you delegate the responsibilities between family members, but even then communication can break down. Instead, use your website to disperse information, from driving directions to what pot-luck dishes to bring. Best of all, after the event, you can use the site to share all the pictures that were taken.

Party Invitations

A single page on your site can serve as a party invitation. You can include the link

in email invitations that you send out to friends and family. If you want it to be private, some hosts will allow you to password the page.

Add a link to a guest book, and participants can RSVP and add their pot-luck plans. If the party's guest of honor has a bridal or gift registry, that information can be posted as well, along with a link to the store's website. Likewise, a link can be set up to the guest of honor's favorite charity for donations in her name.

Class or Family Reunions

You can use a website to orchestrate a class or family reunion. Begin by announcing the event and giving links to hotels and mapping sites such as MapBlast or MapQuest. Next, you can post pictures, stories and memorabilia from the old days. Then solicit pictures and stories from others and post these as well.

This Page: Party invitations can be single pages that announce the event or include links to driving directions and more. In the near left mermaid example, the web designer added a secret "Easter egg" link—if you click the back pumpkin, you get additional details such as the address for the party.

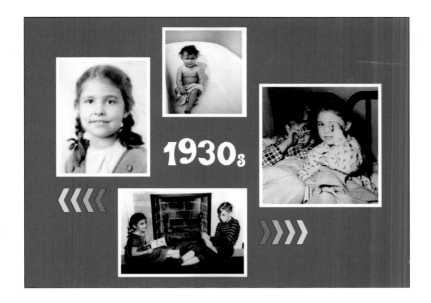

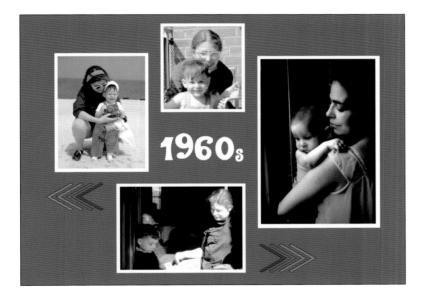

Above: Your "70th Birthday Celebration" site can be as simple as a photo gallery that is organized by decades. Adding period music for each decade can enhance the mood.

Once you've gathered a nice collection of old prints, make inkjet copies to bring with you. They'll be fun to show and share at the event. It will be even more fun to try and recreate the original poses at the party.

And of course, after the fact, add these and other pictures taken at the reunion to the site for everyone to enjoy.

Art of Storytelling

Your website is the perfect place to let distant relatives share the story of an event. To do this well, you need to do a little planning.

Make a checklist of things to include on the site. Photographs are an obvious choice, but there is other memorabilia that will work as well.

For example, to tell the whole story of your parents' fortieth wedding anniversary, you may want to consider including photos and memorabilia from each decade of their marriage or at least from significant events. This can include:

• Pictures from their wedding or when they first met.

• Scans of baby announcements or congratulations cards from friends and family.

• Newspaper headlines of significant events, such as the first moonwalk.

• A scan of a political candidate's "Vote!" button

• An old logo of a popular product of the day, such as Dad's favorite tobacco or that soda Mom enjoyed.

• Music from the era

• Ask family and friends to send cards with recounted stories. These can then be scanned or transcribed.

• And, of course, take and include pictures of the event itself!

Public & Community Service

A website is a good vehicle for raising awareness and raising funds for your public or community service activities.

Tributes

If you want to pay homage to a hometown hero, a loved one, or an organization, you can build a website (or a page on your site) that celebrates the subject. Yahoo's Geocities even has a template called "Tributes" that makes it easy (left). Or, you can create one with a photo album template.

Support Groups

If you have survived a medical or other crisis and feel you can help others, a support group can be a rewarding and therapeutic activity. You can provide information on coping and links to other sites. Interactivity, such as chat rooms or message boards, would be useful as well.

Fundraising

You can raise funds for your not-for-profit organization with a website. You can give a telephone number or mailing address to take donations. Or, you can take donations online if you work with a host and software that can accommodate secure transactions (e-commerce). You can also utilize a payment service, such as Paypal.com.

Affiliates

Another good way to raise funds is to join a company's affiliates program. For example, you can join the affiliates program of major online booksellers, and then recommend a book related to the theme of the site. If the visitor uses the specified links (provided by the bookseller) to buy the book, you get a commission.

Check around. Some affiliates programs are better than others. Many affiliates also provide banners and links you can cut and paste into your site and instructions for adding them to your site.

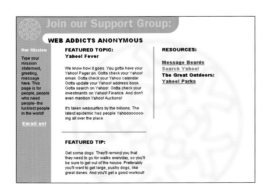

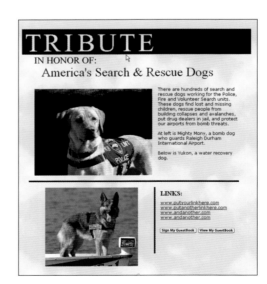

Near Left: Tribute pages, such as this one made on Yahoo/Geocities, can be made for local or national heroes, organizations, and associations.

Far Left: If you have professional expertise or have survived a difficult situation, you can create a support site to help others. Yahoo/Geocities provides this easy template.

Other Cool Additions

Calendars

A calendar or events page is a great way to keep your family, classroom, club, or organization's schedule organized.

Your calendar can be linear (a list) or in traditional calendar format. First look to see if your Internet host or standalone software has an easy template. If not, you can search the Internet for free or inexpensive JavaScript applets under the words "Java" and "calendar."

Some calendars simply indicate what day it is. The nicest versions let you customize the calendar with upcoming events marked with text, clip art, or pictures.

Even fancier are interactive calendars with internal links. Click on the text or photo included on a certain date, and you're sent to a related page with additional information (such as details on a soccer game or driving directions). You can also include an email link for RSVPs, or set up a bulletin board so people can post their potluck plans lest you wind up with 20 plates of brownies and no entree!

Guest Books & Bulletin Boards

Do you need interactivity on your website? Want to give your audience the opportunity to post messages for everyone to read, not unlike a school's bulletin board?

Many WYSIWYG software programs provide options for bulletin boards or similar functions, such as guest books and simple databases. If not, there are many JavaScript applets you can get for free or buy that you simply insert into your site.

More complicated are bulletin boards that require password access. These are nice for preventing pranksters from posting inappropriate information.

If you're having trouble creating a bulletin board or want to maintain more control, you can always elicit the same comments through email and then post them yourself.

Right: Your calendar can be a simple list in chronological order, or one with a decorative, traditional look and internal links to more information.

Right: A guest book is an easy way for your visitors to add comments about your site or ask you questions.

Home Business

If your hobby yields marketable goods or you have a saleable skill, you can run a small business out of your home. A website is a good way to advertise your goods or services. Quilts, sweaters, or refurbished cars can all be sold through a website, as can kittens from prize-winning parentage.

edge artistic design, while your "old-style" store selling handcrafted quilts is better served with a simple, almost folksy look. Likewise, a corporate consultant for a defense contractor would want a more traditional and conservative look. Whatever you decide, it should reflect the spirit of the products you sell.

Trustworthy Appearance

Your business site should be professional and appropriate for your market. "Professional" does not mean stiff and boring. It means appropriate for your target customers and communicating trustworthiness.

A graphic designer's (or pet portraitist's) website might do better with a cutting-

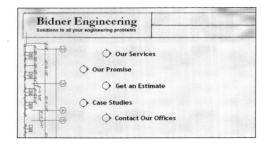

Attracting Visitors

You can't sell anything on your site if no one sees it! You don't want to break the Internet "rules of conduct" and spam strangers or e-groups with email sales pitches, but what else can you do?

1. Get listed on search engines. See pages 78 and 138 for more information.

2. Provide educational information of interest to your potential customers. If you want to sell a huge baseball card collection, you can attract enthusiasts by including: educational information on

Left: There are no rules to designing your business-related site *except* that it should look trust-worthy and be appropriate for your market (such as the homey feel of the handcrafted quilt site). Quick templates and clip art allowed me to quickly produce these three sites in Homestead's SiteBuilder LPX software.

Below: You can attract people to your site with helpful tips and links. Once there, you can provide a page with recommended reading suggestions. If they click on the book for more information, they're sent to an online bookseller with whom you are an affiliate. If they buy the book, you earn a commission!

collecting; links to clubs, associations, and swap shows, and baseball history. While the visitor is surfing your site, he may decide to browse your store and buy.

3. Start an e-newsletter that brings information on a topic of interest to your potential buyers. Resist sending this email to people who did not specifically request it (that's considered spam).

4. Start an e-group on a topic of interest to your potential buyers. An e-group allows members to send out questions to the membership pool, and other members can give advice. Usually, the member has the choice of receiving all the questions and answers as individual emails, as weekly digests (compilations), or reading them on the homepage of the group. One popular e-group host is Yahoo.

Earn Money through Affiliates Programs

One of the easiest home businesses to start is to join the affiliates program of a major company. An affiliates program is the Internet version of a sales commission. You register as an affiliate with a company that has a program. Then you tell your visitors about some of their products and provide special links to their site. (The affiliate host has banners, links, and other information you can cut and paste into your site.)

If your visitors end up buying those (or other) products, you get a commission. Read the fine print in the affiliate's terms and conditions page. Some affiliates programs are better than others.

Affiliates programs work best if the recommended products are related to your website theme and are therefore of interest to your visitors.

For instance, you could put together the world's greatest site on ferret training, then join the program of a large pet supply company and list their best, hard-to-find ferret products. You could also join an online bookseller's affiliates program and link to the best manuals on ferret training.

Recommended Reading

4 gardeners

home
top tips
shop
FAQs
links
contact

Garden Lighting, Outdoor Entertaining
Combine mini-lights with handmade paper, plants, and cans. Transform ordinary electric walkway lights with shiny brushed tin or candles in decorated gourds.

Making Garden Floors
Improve your garden with these essential floor "show-hows." Real-life garden transformations and recipes for paving.

Making Arbors & Trellises
Using simple equipment, anyone can make attractive arbors from 25 beautiful designs for gardeners and woodworkers alike.

Garden Walls, Fences & Hedges
Step into your garden—what do you see? With the right wall, fence, or hedge, it will look better and be more functional!

Online Resumes

Job-hunting? You can outline your skills on your site, and even include a link to a downloadable version of your resume (see page 83).

Unless your family life is a selling aspect for a prospective employer, it's best to have a separate site for your job-hunting or work. Some Internet hosts let you have several site names, such as www.home-stead.com/bidner and /bidner1, provided you don't go beyond the overall file size limitations of the hosting service to which you have subscribed.

E-Commerce Capability

If you plan on selling products or services from your site, you'll want to consider your options for accepting payments. The easiest method is to simply provide an address and only accept mailed-in checks or money orders.

If you already have an account for accepting credit cards, you can take credit card orders by telephone. The credit card information can also be faxed. Less secure are emails, so it is recommended that the credit card be sent in two parts—the first eight numbers in one email and the last eight in another.

Online Transactions

Truly secure online transactions require advanced software ad servers. This software can either be purchased or is available online with hosts who offer e-commerce capability.

Still another option are online payment services made popular by eBay and other auctioneers. A company, such as Paypal or AuctionPay, acts as intermediary (for a fee). The buyer pays the company via credit card, wire transfer, or check. The company then credits your account. This money can be withdrawn by wire transfer or check, or held in the account should you want to buy something from someone else.

Your Auction Page

Are you addicted to eBay or other online auctions? Do you have a closet or attic full of things ready to sell? If you've browsed the auctions, you'll find that many of the top sellers include links to their personal websites. This serves several purposes:

1. You establish your professionalism and give potential buyers confidence in you as a seller.

2. You can show more pictures of the item without having to pay the per-picture premium.

3. You can list other items for sale. Since the visitor is already predisposed to this type of product, you have a good chance of selling additional items.

Auction Annie's
other great buys!
Click to Enter

Choose from 100's of WWI photos and postcards. Buy three and receive a 10% discount.

Auction Photos

Let's face it: A lot fewer people are going to bid on an item in an online auction if the listing doesn't show a picture. They're nervous enough buying online, so a good photograph will go a long way toward building consumer confidence in you as a seller.

Lighting can make a big difference in how your product photos look. Most objects will look nice if shot under the soft light from a north-facing window or outside on an overcast day. Indoors, you can resort to your camera's built-in flash, but this usually creates unflattering frontal lighting and can cause reflections on shiny surfaces.

Another important factor is your choice of backgrounds. Your goal is to create a non-distracting, background for your product. A table with a neutral-colored cloth can work well. Or place the subject on the ground with a sheet or swatch of fabric draped under and behind it. Quality velvet is the ideal fabric because it hides drapes and wrinkles. If you're adept in photo-editing software, you can silhouette the background (see page 71).

If your camera has close-up capabilities, you can move in to take pictures of the details or defects of the item. You can also create the "close-up" by cropping the picture later to show only a small portion of the original.

Appendix A
Resources & Suppliers

Please note that every effort has been made to supply accurate website addresses in this section. However, Internet businesses and their websites are apt to change more frequently than a book can be updated. If an address does not work, check back the next day, as the site may have been experiencing difficulties. Or, do a key word search under the company name for a more up-to-date address.

Web-Building Software

AceHTML (Visicom Media)
http://freeware.acehtml.com

Arachnophilia (Arachnoid)
http://www.arachnoid.com

Authorware (Macromedia)
www.macromedia.com/software

Cool Page (Cool Page)
www.coolpage.com/cpg.html

CuteHTML (GlobalSCAPE)
http://www.cuteftp.com/cutehtml

CuteSITE Builder
(GlobalSCAPE)
http://www.cuteftp.com/cutesitebuilder

Dreamweaver (Macromedia)
www.macromedia.com

Fireworks (Macromedia)
www.macromedia.com

1st Page 2000 (EVR Soft)
www.evrsoft.com/products

FrontPage (Microsoft)
www.microsoft.com

Fusion (NetObjects)
www.netobjects.com

GoLive (Adobe)
www.adobe.com

HTML Editor
(CoffeeCup)
www.coffeecup.com

HomeSite (Macromedia)
www.macromedia.com/software/homesite

HotDog Junior (HotDog)
www.sausage.com

HotDog Professional (HotDog)
www.sausage.com

Interland/Trellix
www.interland.com

Internet Design Shop XL
(Boomerang)
www.boomerangsoftware.com

Namo WebEditor (Jasc Software)
www.jasc.com

Netscape
http://wp.netscape.com

PageWiz (HotDog)
www.sausage.com

WebEasy (VCOM)
www.v-com.com

Photo Editing Software

Digital Image Pro (Microsoft)
www.microsoft.com

ePhoto Album (Picture Gear)
www.picturegear.com

Elements (Adobe)
www.adobe.com

FlipAlbum (FlipAlbum)
www.flipalbum.com

Paint Shop Pro (Jasc Software)
www.jasc.com

Photobook (Corel)
www.corel.com

PhotoImpact (Ulead)
www.ulead.com

Photoshop (Adobe)
www.adobe.com

PhotoSoap (Scansoft)
www.scansoft.com

PhotoSuite (MGI)
www.roxio.com

Picture IT (Microsoft)
www.microsoft.com

Web Graphics Software

Ace Design Pro
(Visicom Media)
http://www.visicommedia.com/acedesign

Animation.Applet (Ulead)
www.ulead.com

Animation Factory (Visicom Media)
http://www.visicommedia.com

Animation Shop (Jasc Software)
www.jasc.com

Art-o-matic (Cool Page)
www.coolpage.com/aom.html

Button Factory (CoffeeCup)
www.coffeecup.com

ButtonFly (Visicom Media)
www.visicommedia.com/buttonfly

CoffeeCup GIF Animator (CoffeeCup)
www.coffeecup.com

Effects Factory (CoffeeCup)
www.coffeecup.com

Firestarter (CoffeeCup)
www.coffeecup.com

GIF Animator (Ulead)
www.ulead.com

Headline Factory (CoffeeCup)
www.coffeecup.com

ImageLab (HotDog)
www.sausage.com

Java Animator (HotDog)
www.sausage.com

JavaScript Tools (HotDog)
www.sausage.com

KidPix Deluxe (Broderbund)
www.kidpix.com

PhotoObjects (CoffeeCup)
http://www.coffeecup.com

Text Effects (HotDog)
www.sausage.com

Visual Table Editor (HotDog)
www.sausage.com

Other Software

AfterEffects (Adobe)
www.adobe.com

CuteFTP (GlobalSCAPE)
www.cuteftp.com/cuteftp

eLearning Suite (Macromedia)
www.macromedia.com

ePhotoAlbum (Picture Gear)
www.picturegear.com

FlipAlbum Virtual Albums (E-Book Systems)
www.flipalbum.com

HotDog Junior (HotDog)
www.sausage.com

Illustrator (Adobe)
www.adobe.com

Kai's Super Goo (ScanSoft)
www.scansoft.com

LiveMotion (Adobe)
www.adobe.com

Paint Shop Photo Album (Jasc)
www.jasc.com

Password Wizard (CoffeeCup)
http://www.coffeecup.com

PhotoFactory (Scansoft)
www.scansoft.com

PhotoShow (Simple Star)
www.simplestar.com

Premier (Adobe)
www.adobe.com

SoundEdit 16 (Macromedia)
www.macromedia.com

3D-Album
(Micro Research Institute)
www.3d-album.com

Virtual Painter (Jasc Software)
www.jasc.com

WebCam (CoffeeCup)
www.coffeecup.com

Web Graphics Book (Jasc Software)
www.jasc.com

WebSource
www.web-source.net

E-Commerce

Auction Payments (Western Union)
www.auctionpayments.com

eComm Store (Trellian)
www.trellian.com/ecommstore

PayPal (eBay)
www.paypal.com

StoreFront (LaGarde)
www.storefront.net

WebShop Designer (Boomerang)
www.webshop5.com

Genealogy

Ancestry.com
www.ancestry.com

Ancestry Family Tree
www.ancestry.com

Family Tree Maker
www.geneology.com

Master Genealogist
(Wholly Genes)
www.whollygenes.com

My Family
www.myfamily.com

My Roots (Green Maple)
www.greenmaple.com/myroots

RootsWeb (My Family)
www.rootsweb.com

Search Engines

Lycos
www.lycos.com

Google
www.google.com

AltaVista
www.altavista.com

Hotbot
www.hotbot.com

MSN Search
www.msn.com

AOL Search
http://search.aol.com

Search Optimization

Search Engine Forums
www.searchengineforums.com/

Search Engine
Optimization Pros (SEO)
www.seopros.org

Search Engine Resource Center
www.searchengines.com/

Search Engine Watch
www.searchenginewatch.com/

Webmaster World
www.webmasterworld.com/

WebPosition Gold (Cool Page)
http://www.webposition.com/

Web Hosts

America Online (AOL)
www.aol.com

BaBaBabies
www.bababbabies.com

BlueDomino (CoffeeCup)
http://www.bluedomino.com

Comcast Broadband Personal Pages
www.comcast.net

Earthlink
www.earthlink.net

EasyWeb (ABT)
http://www.easyweb.abtnet.com

EduHound Espanol (eduHound)
(Spanish-Language)
http://www.eduhound.com/espanol

EZ Kid Web
www.ezkidweb.com

Geocities (Yahoo)
http://geocities.yahoo.com

Go Daddy
www.godaddy.com

Homestead
www.homestead.com

Hotlists (EduHound)
http://www.eduhound.com/hotlist

My Family
www.myfamily.com

MySchoolOnline
www.myschoolonline.com

Net Zero
www.netzero.net

PeoplePC Online Ultimate
www.peoplepc.com

PowWeb.com (Visicom Media)
http://www.powweb.com

Roots Web (My Family)
www.rootsweb.com

Sausage Hosting (HotDog)
www.sausagehosting.com

Tango Interactive
www.tangointeractive.com

Tripod/Lycos
(Terra Lycos Network)
www.tripod.lycos.com

Fonts, GIFs, & JavaScript

Animation Factory
www.animfactory.com

Awesome Clipart for Kids
(EduHound)
www.awesomeclipartforkids.com

FireStarter (CoffeeCup)
www.coffeecup.com/firestarter

Flash (Macromedia)
www.macromedia.com

FontFace
www.fontface.com

Free GIFs & Animation (FG-A)
www.fg-a.com

Harold's Fonts
www.haroldsfonts.com

Internet ClipArt
www.internetclipart.com

JavaScript Resource
www.javascript.com

JavaScript Source
http://javascript.internet.com

KoolMoves
www.koolmoves.com

Webmonkey (Lycos)
www.webmonkey.com

WebSource
www.web-source.net

Internet Information

World Wide Web Consortium
(W3C)
www.W3.org

InterNIC
www.internic.net

Webmonkey
www.webmonkey.com

Glossary

A

Affiliates Program: A program offered by some online retailers that allows you to collect commissions.

Aliasing: See *anti-aliasing*.

Anti-aliasing: A function that tries to eliminate the jagged appearance of letters on your website (*aliasing*). Works best on a type size over 12 points.

B

Brightness: A photo-editing software function that can lighten or darken a digital picture.

Browser: A software interface program that allows you to access the Internet. Internet Explorer and Netscape are popular examples.

Burn: A software function that can darken a portion of a digital picture.

C

Cascading Style Sheet: A web design function that streamlines the setting of style rules for your entire site.

Clip Art: Free or inexpensive digital illustrations, animations, or photos that can be added to your website.

Contrast: A photo-editing software function that can increase or decrease the breadth of tones in a digital picture.

Copyright Law: An international law that is designed to protect photographs (and other creations) from being used without the permission, knowledge, and/or compensation of the creator.

D

dHTML (Dynamic HyperText Markup Language): A web-design language that combines HTML with JavaScript, Cascading Style Sheets, and other web-design languages.

Digitize: To turn an analog (conventional) photograph or video into a computer-friendly format.

Dodge: A software function that can lighten a portion of a digital picture.

Domain Name: An alphanumeric name (usually sandwiched between "www." and ".com") that directs Internet visitors to your website.

Downloading: Transferring information from an Internet source to your computer.

DPI (Dots per Inch): A measurement function that defines the number of dots in a conventional print. Often used interchangeably with *ppi* (see below).

DV (Digital Video): "Movies" that are saved in a computer file format rather than on videotape or film.

E

E-commerce: Selling on the Internet.

E-tailer: A business that sells its goods or services via the Internet.

Encoding: Turning video into web-friendly format.

F

Fill Flash: A feature that fires the camera's built-in or accessory flash to add some front lighting to the subject.

Filter: In photo-editing software, filters, such as SHARPEN or BLUR, are used to make alterations and enhancements to a digital photo.

Flash Graphics: A program for creating animation and interactive modules that can be integrated into your website.

Font: Another word for typeface. TIMES and HELVETICA are common fonts.

Frames: A web design structure that divides your website into "minipages." Frame structure is often used to create an upper- or left-hand column for navigation.

FTP Protocol: A software function that allows the easy upload and transfer of your website design files to your Internet host.

G

GIF (Graphics Interchange Format): A picture and animation format that displays up to 256 colors, making it a good choice for creating graphics with small file sizes but a poor choice for quality photographs.

H

HTML (Hypertext Markup Language): A computer language and format often used in website design.

Hexadecimal Code: A six-digit alphanumeric description of a specific color.

Homepage: The first or only page in your website.

Host: The company that "houses" your website, allowing visitors to access it.

Hyperlink: A word or graphic that, when clicked with a mouse by a visitor, jumps her to another page, website, email window, etc.

I

Internet Service Provider (ISP): The company that enables you to access the Internet from your computer.

J

JavaScript: A web-design language, most often seen in mini-programs called "applets" that perform certain tasks.

JPEG (Joint Photographic Experts Group): A picture format that is a good choice for digital photos on your site.

L

Layers: A design capability that allows graphic elements to be "stacked" and "shuffled" so they overlap in different ways.

Link: See *hyperlink.*

M

Metatags: A usually hidden code that describes the content of your site. Metatags are especially important if you want your site to be listed on *search engines.*

MIDI: A file format for digital sound.

MNG (Multi-Image Network Graphics): A web-oriented file format that supports animation.

MP3: A file format for digital sound.

N

Navigation Aids: A word or graphic that, when clicked with a mouse, will send your visitor to another page, website, email, etc.

P

PDF (Portable Document Format): A compact file format that takes a "snapshot" of a page design so that it can be downloaded and printed exactly as intended.

Pixel: A single picture element that, when combined with others, creates a digital photograph.

PNG (Portable Network Graphics): A web-oriented picture format that is a good choice for photographs.

PPI (Pixels Per Inch): A measurement function that defines the number of picture elements (*pixels*) in a digital picture and is used to express *resolution.* Often used interchangeably with *dpi.*

R

RealAudio: A file format used for digital music and audio.

Removable Storage Media: Floppy disks, Zip disks, CDs, digital camera memory cards, and other media designed for saving and transferring digital files.

Resolution: An expression of how many picture elements (pixels or dots) make up a particular digital image. See *dpi* and *ppi*.

Rolling Paragraphs: Paragraphs that automatically readjust their size depending upon how large the visitor chooses to view the site.

S

Scanner: Hardware that allows you turn a print, slide, negative, or relatively flat memorabilia or art into a digital picture file.

Search Engine: An automated program that searches websites and categorizes them by searchable key words.

Sharpen: A photo-editing software function that can help improve sharpness of slightly soft images.

SLR Camera: A single-lens reflex camera, often associated with professional photography.

Source Code: A term for the computer language that describes how a website should look and function.

Spider: A slang name for a type of search engine that automatically and systematically searches websites on the Internet and then categorizes them by key words. See *metatags*.

T

Tables: A way of organizing data, words, or pictures on a website that is similar to creating tables in a word-processing software program.

Template: A pre-designed website file meant to speed up web design. The user simply substitutes her own photos, graphics, and text for the placeholders in the template.

Text Box: A design element in *WYSIWYG* web design software that contains text. It can usually be edited, moved, resized, and otherwise altered.

Thumbnail: A small digital photograph, usually linked to a larger version.

TIFF (Tagged Image File Format): A digital picture format that is good for reproduction in books but not appropriate for Internet usage

Typeface: See *font*.

U

Uploading: Transferring information from your computer to an Internet source.

V

Virtual Albums & Galleries: A visual presentation of photographs designed to look like a real photo album or three-dimensional environment on your computer.

W

Watermark: A visible or invisible mark that distinguishes a digital photograph. It is generally used as a way to display *copyright* information and minimize illegal use of the image.

Wave: A file format for digital music and sound.

Web-Safe Palette: 216 colors that reproduce reliably on most computer monitors.

World Wide Web (WWW): A term that originally referred to the commercial sector of the Internet but is now synonymous with the Internet as a whole.

WYSIWYG: An abbreviation for "What you see is what you get." WYSIWYG software lets you build your site visually without knowing HTML, JavaScript, or other web-design languages.

Index